Look into My Eyes:
Nuevomexicanos por Vida, '81–'83
Kevin Bubriski

Foreword by Miguel Gandert

Museum of New Mexico Press
Santa Fe

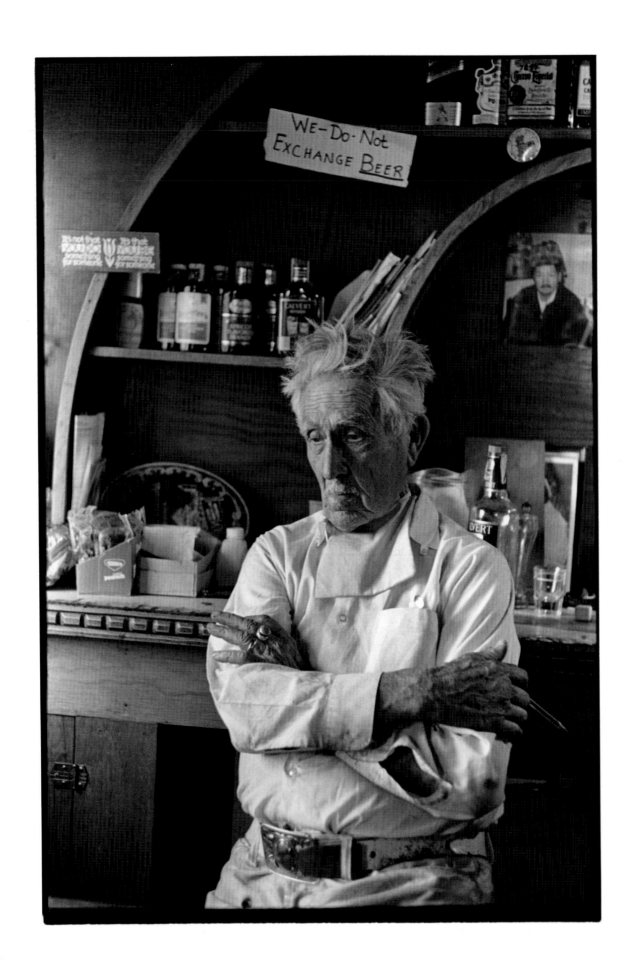

Contents

Foreword
Miguel Gandert

A young Nuevomexicana peers out the back window of what appears
to be a 1950s Chevy. Wearing painted eyebrows and a flannel shirt, she looks
through the camera, through the photographer—an intimate stare that has
haunted me since I first laid eyes on the image some thirty years ago. It is not
often that I wish I had made someone else's picture, but when I was asked to
write this foreword, I again felt envious of the photographer who had captured
that brief personal moment. The author of the fine images in this volume is Kevin
Bubriski. A New Englander by birth, Kevin came to New Mexico in 1981 to study
film. By the end of his first summer he was freelancing, working on newspaper
and magazine assignments. The camera became his muse and he began more
serious explorations of the people and places of New Mexico.

In 1984 Kevin and I exhibited together in a show sponsored by the Santa
Fe Center for Photography. *Burque*, a slang term for Albuquerque, was the exhi-
bition title. I believe Kevin came up with it. Kevin, like me, would be considered a
documentary photographer, our special memories, moments, and stories captured
within single frames. During the period when the photographs in this book were
created, we both followed similar paths—35-millimeter cameras, black-and-white
film printed full-frame with black borders created in the darkroom. A filed-out
negative carrier showing the edge of the negative as a black border is a state-
ment: the image is complete as soon as the shutter is released—no cropping.

I can still remember meeting Kevin for the first time and although we
spent little time together, a friendship—probably based on the spiritual link
found in our work—developed. Kevin is a quiet and intense man. He is sensitive
and open to Nuevo México, a world unlike the Northeast, where he grew up, and
Nepal, where he spent time after college in the Peace Corps. It was the early
1980s, two photographers working in similar communities, yet each man's vision
was uniquely his own. Both of us were searching for truth and beauty to save
these moments that scream to the world, "Look what I've seen! Isn't it wonder-
ful?" Kevin was respectful of Hispano New Mexico. His feelings for this place are
revealed in the way his subjects have accepted him and the intimate way he has
entered their world.

The images in this volume are not just about an artist with a camera, but rather are about an exploration of time and place—Burque, Chimayó, Española, Santa Cruz, El Rito, Santa Fe—communities whose inhabitants are filled with ethnic pride. Kevin has given his subjects a voice; as the photographer, he asks us to look into their eyes and appreciate the dignity that he saw.

But there is also a tremendous attention to detail—cars framing the faces of young people, bicycles, horses, and, of course, relationships—young couples in love and groups of young men. Especially beautiful is the image of a wedding, where, in dance, a groom spins the bride. She appears as an angel, her veil-like wings floating within the middle of a group of friends. The images resonate with a fidelity to the heart of the people. Looking back now, through time, I see that Kevin has captured a series of powerful moments in our community.

In New Mexico, often referred to as the Land of Enchantment, the tourist gaze haunts our collective image: the romantic pictures of Native Americans, cowboys, and conquistadors, and beautiful landscapes by O'Keeffe. In the early 1980s a photographer seldom looked at Nuevomexicanos, a group that was, and continues to be, marginalized. Kevin's gaze is direct and reverent. The images reveal an artist who is open to the magnetism and energy of La Raza.

We are lucky to have these images returned to us. That they were not lost to history makes me appreciate the fragility of time. I remember many pictures from our exhibit thirty years ago; others are like new friends, all of them clear and poignant memories. I am glad Kevin has returned these images to us so that we can look again into our past—the beauty and energy, a slice of time.

I have followed Kevin's career over the years, during which time he has produced extraordinary work in Nepal, Japan, and throughout Asia. The photographs he created in New Mexico can be linked to his later work, in that wherever he has traveled, he has shown a respect for the people he meets on his journey. The tools may have changed—the 35-mm camera from his New Mexico years evolved into a large-format 4 x 5-inch camera mounted on a tripod for Nepal—but his use of black and white has been a constant. I see the vision he was formulating here as a young photographer, gaining trust and communicating with his subjects, and the influence it had as he refined that skill in his later, mature work.

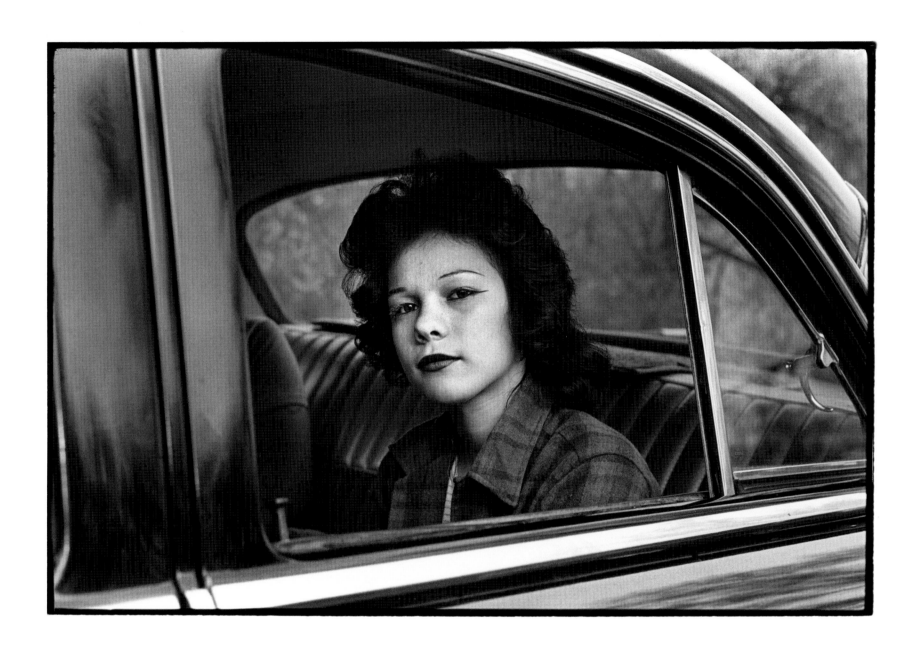

3. San Gabriel Park, Albuquerque, 1983

4. Truchas, 1982

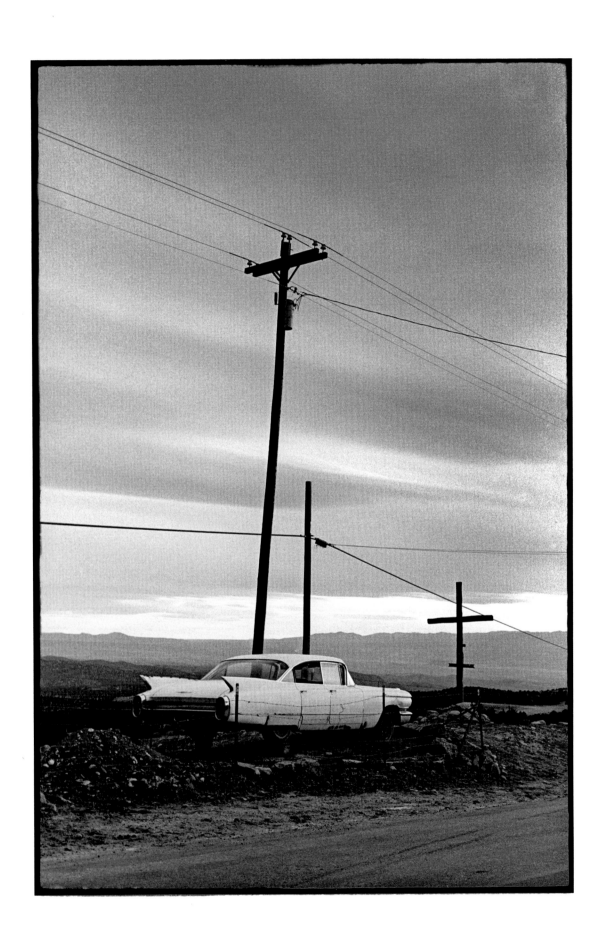

5. Holy Thursday, Chimayó, 1982

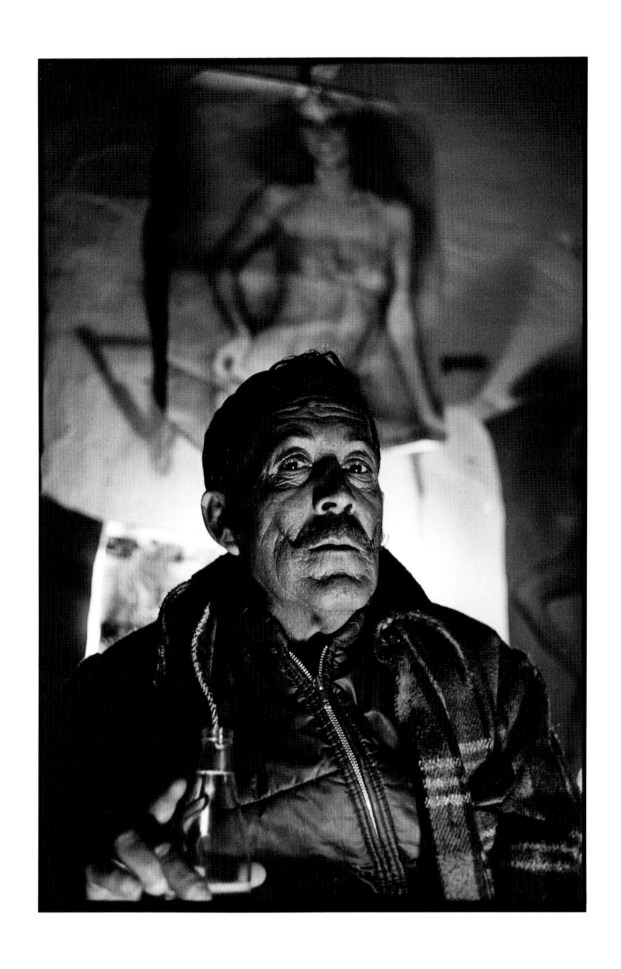

Photographer's Introduction
Kevin Bubriski

The thick sweet smell of piñon smoke hung in the bitter-cold night air when I first pulled into Santa Fe. It was almost midnight in early January 1981. I had left Tulsa, Oklahoma, that morning in a worn, compact Renault sedan that I had learned to drive just the week before on the icy roads of Massachusetts. One tank of gas got me from Massachusetts to western Pennsylvania on my first day of driving. The next day, another tank of gas got me to St. Louis. The third day, a third tank carried me to Tulsa.

My first months in Santa Fe were spent on Upper Canyon Road, studying documentary filmmaking at the Anthropology Film Center with Carroll and Joan Williams and their extended family of aging hound dogs. Between puffs on his Camels, Carroll taught the mechanics of heavy 16mm Arriflex, NPR, and Aton cameras; Nagra tape recorders; and 16mm film. I loved the solidity and physical integrity of the machines with which we learned to capture moving images and sound.

On Holy Thursday, with both hand-cranked 16mm Bolex and 35mm Leica cameras in hand, I came upon Santa Fean Leroy Perea on his solitary walk of penance, heading north through Nambé to the Santuario de Chimayó. Perea carried a large, homemade wooden cross over his shoulder. He walked alone, a day before throngs of teenagers, old people, and whole families would fill the roads on the Good Friday pilgrimage. The devotion of the Chimayó pilgrims stirred in me a deep curiosity about, and appreciation of, the cultural richness of Northern New Mexico.

During the summers of 1981 and 1982, I worked in Chimayó with independent filmmaker Pacho Lane on *Los Moros y Cristianos*, his documentary about the village's summer fiesta and its horseback reenactment of the battle between costumed Moors and Christians of the Crusades. Local residents wielded swords, shields, and banners for the pageant. It was an entry into the lives of the people of Chimayó and residents like Percy Luján who invited us into their family homes and daily activities. Our cameras, too, were welcome.

I was already a still photographer before I arrived in New Mexico, and I loved the immediacy of connection and result I could achieve with a small hand-held 35mm camera and a few rolls of film that cost a few dollars apiece. As I had found in Chimayó, interesting subject matter was all around me in New Mexico. A spirit of spontaneity, curiosity, and enthusiasm spurred me to find my way to

15

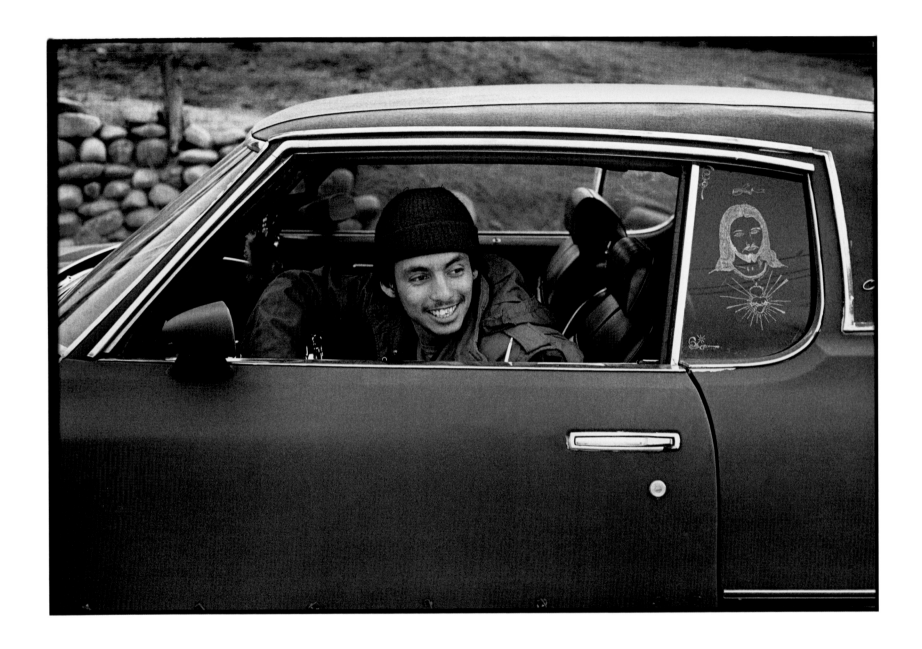

6. Holy Thursday, Chimayó, 1982

the subjects of my photographs, and I made a point of attending every fiesta, parade, celebration, and religious observance I heard about and had the gas money to get to. I also found a vibrant and supportive photography community in Santa Fe, with many local photographers who were willing to lend me a hand and trade darkroom time for my help in their studios. My love of still photography won out over my fascination with moving pictures.

It was an exciting time to be a young photographer in New Mexico. In Santa Fe I worked as a freelance photographer for *The New Mexican* newspaper, printed fine-art photographs for French photographer Bernard Plossu, and made new friends in the Santa Fe and Albuquerque photographic worlds. In the summer of 1982 a full-time photography position opened up at the *New Mexico Sun* newspaper in Albuquerque. I was offered the job—loaded up all my worldly belongings, negatives, prints, and cameras into my car—and headed an hour south to the big city. My Albuquerque days were faster-paced and less picturesque than those I left behind in Santa Fe. But the experiences were very real, as I drove seventy to a hundred miles each day in and around the city, chasing stories the editors assigned. Deadlines meant moving quickly, getting back to the office, processing film, editing contact sheets, and printing final photographs to get to the managing editor before press time.

The job taught me discipline, professionalism, and familiarity with the different neighborhoods of the city, spots both well-known and largely hidden. Whenever I had free time, I drove around parts of the city that were photographically appealing. I was especially drawn to San Gabriel Park and other areas where Burque youth would gather. Although I was working as a news photographer, on my own I was looking for images that I enjoyed for their own visual merit and innate curiosity. These were my favorite images, but they were not the photographs I gave to my editors or that would have interested the publisher. In my own time I had immense freedom to explore. On New Year's Eve 1983, I chose to photograph the night at Albuquerque's La Bamba Club, knowing that Al "Hurricane" Sánchez would be playing. Though I had my camera with me, I celebrated the New Year with a lounge full of new friends.

In late spring 1983, graphic designer Marilyn García, with her delicate sense of pace and visual acumen, beautifully designed a selection of my photographs into book form. The work sat quietly on a shelf for thirty-two years, waiting for the right moment. Almost four decades past, these images from New Mexico in the early '80s return me to the excitement and sense of discovery I felt as a young photographer experiencing this enchanted land for the very first time.

Nuevo México 1981–1983

7. Holy Thursday Pilgrimage to Chimayó, 1982

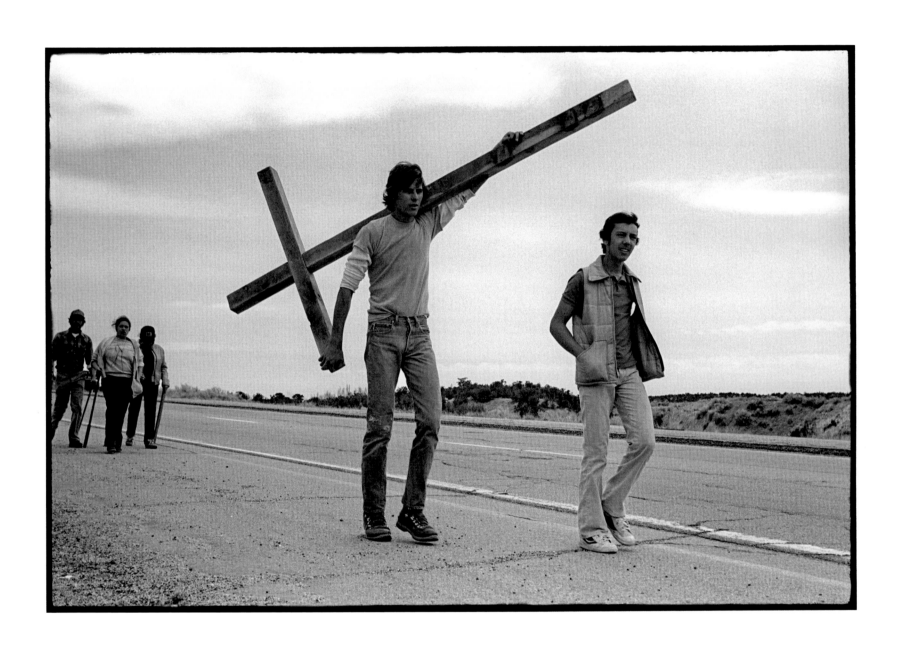

8. Good Friday, Chimayó, 1982

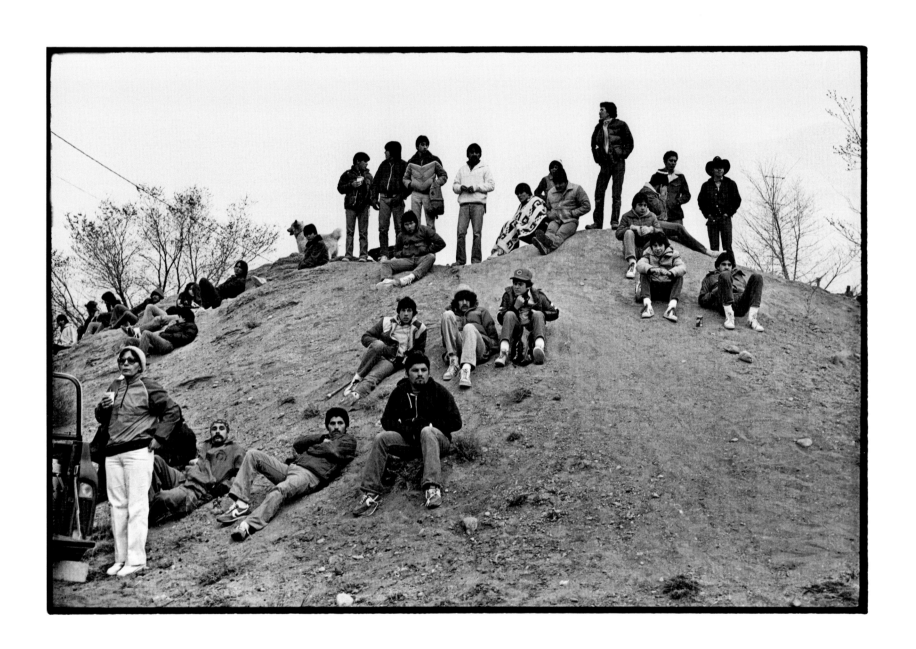

9. Good Friday, Chimayó, 1982

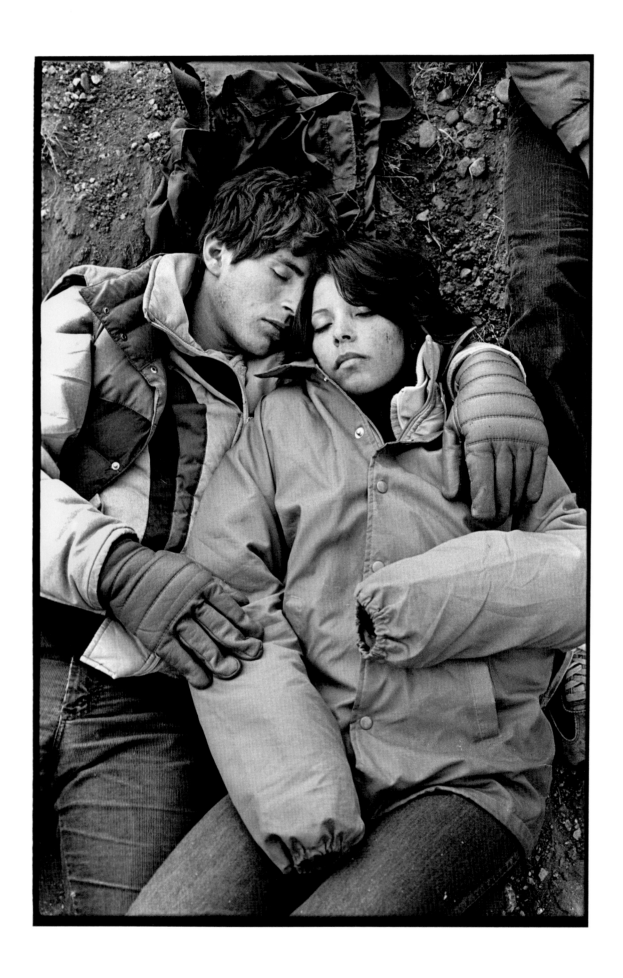

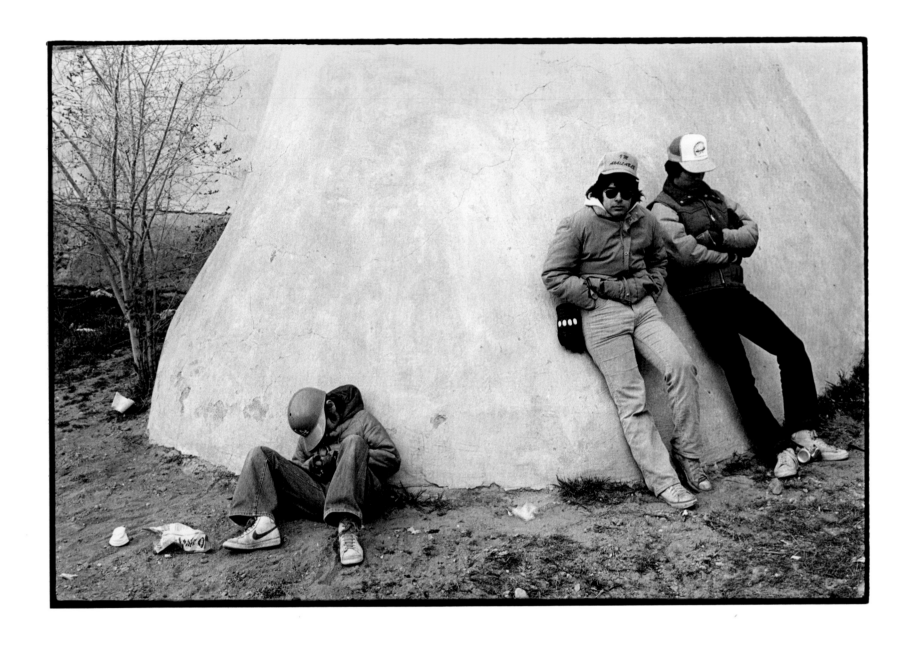

10. Good Friday, Chimayó, 1982

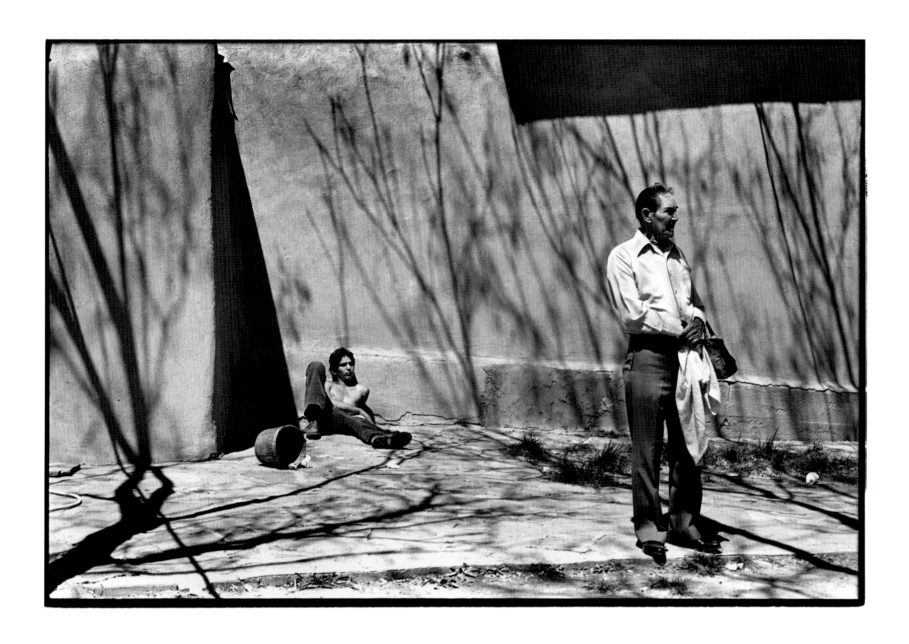

11. Good Friday, Chimayó, 1981

12. Chimayó, 1982

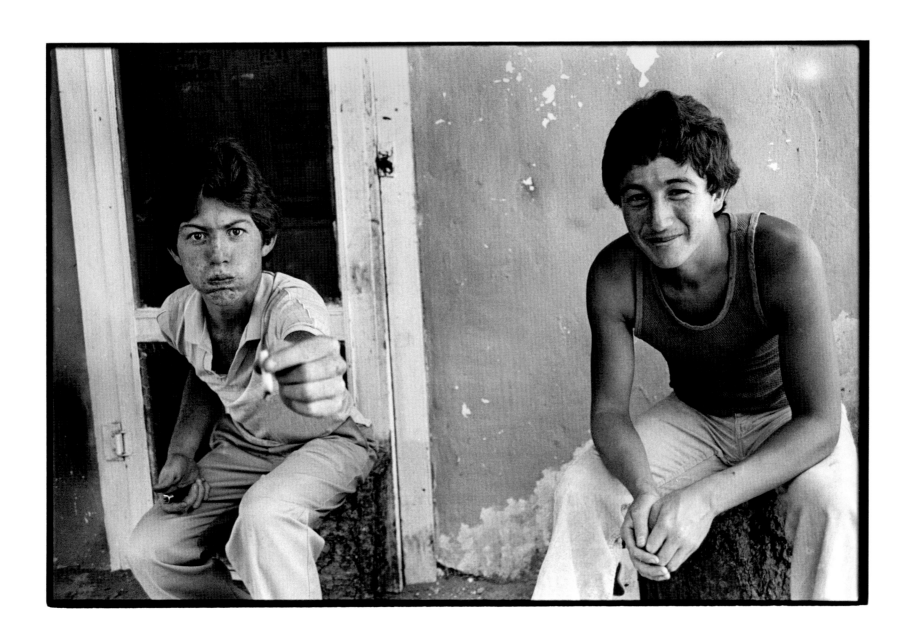

13. Fiesta Queen, Santa Fe Rodeo, 1982

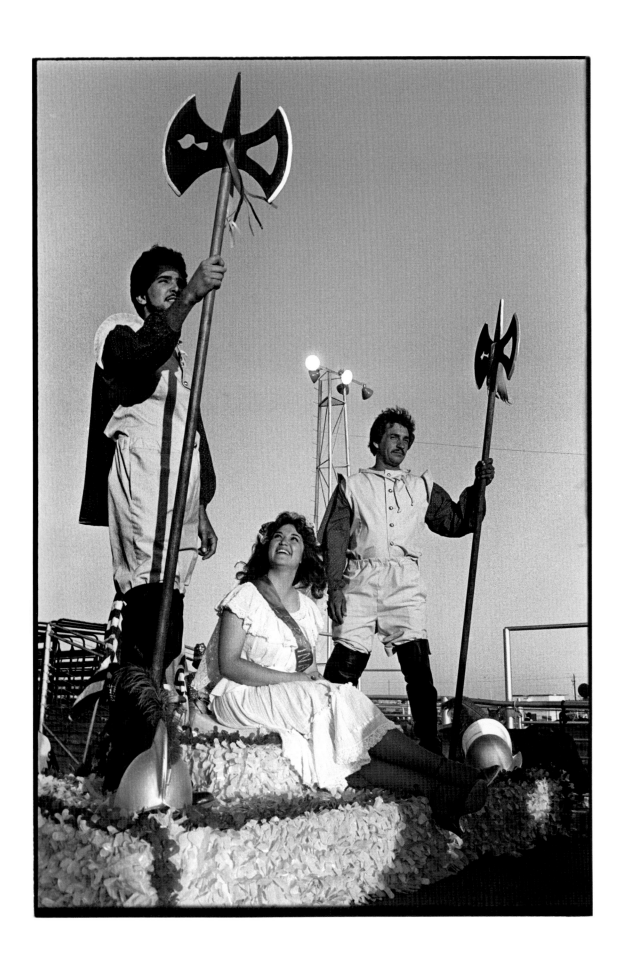

14. Percy Luján, Chimayó Fiesta Parade, 1982

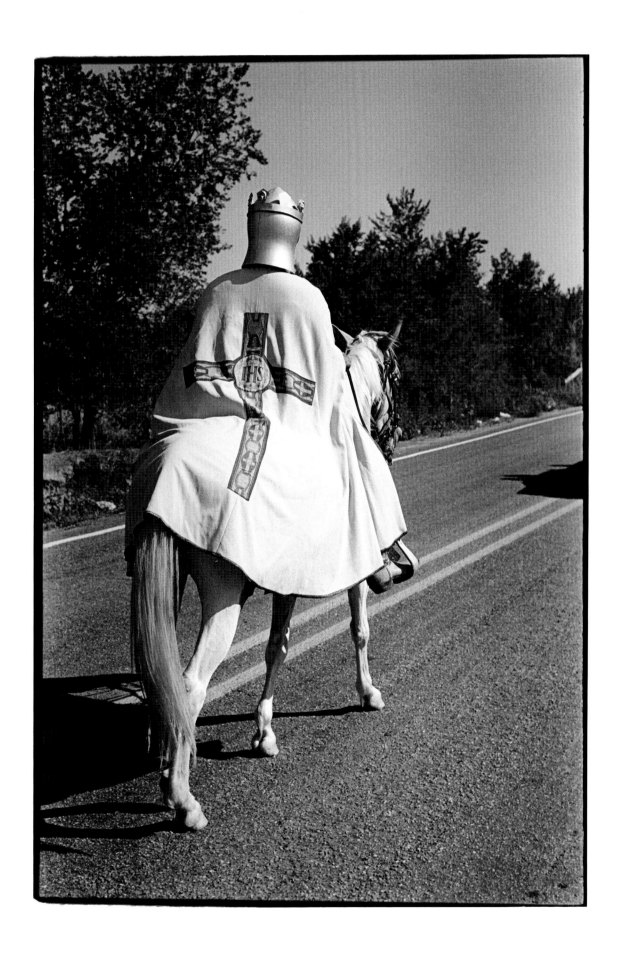

15. Lowrider Bikers, Chimayó Fiesta Parade, 1982

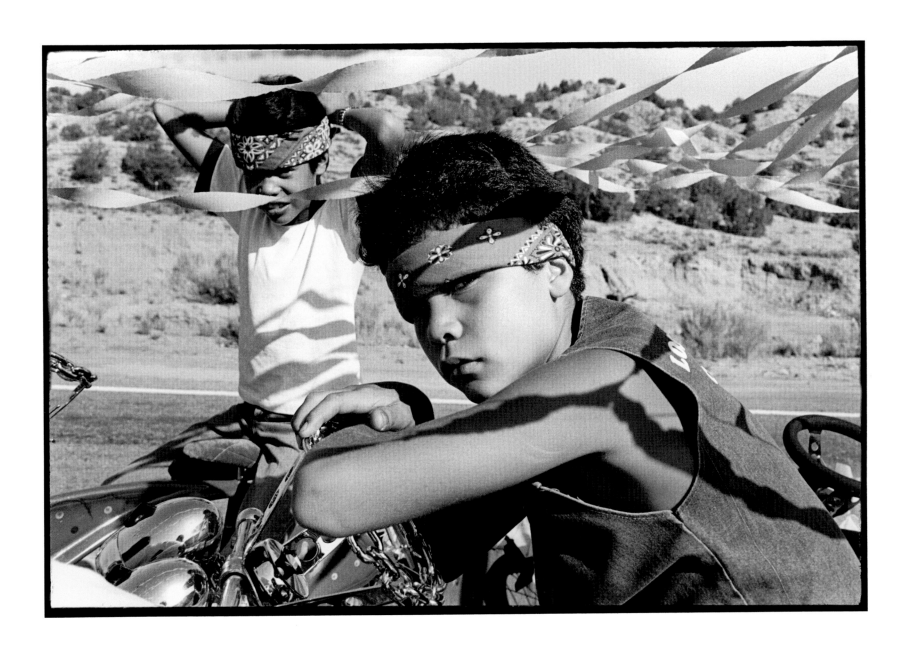

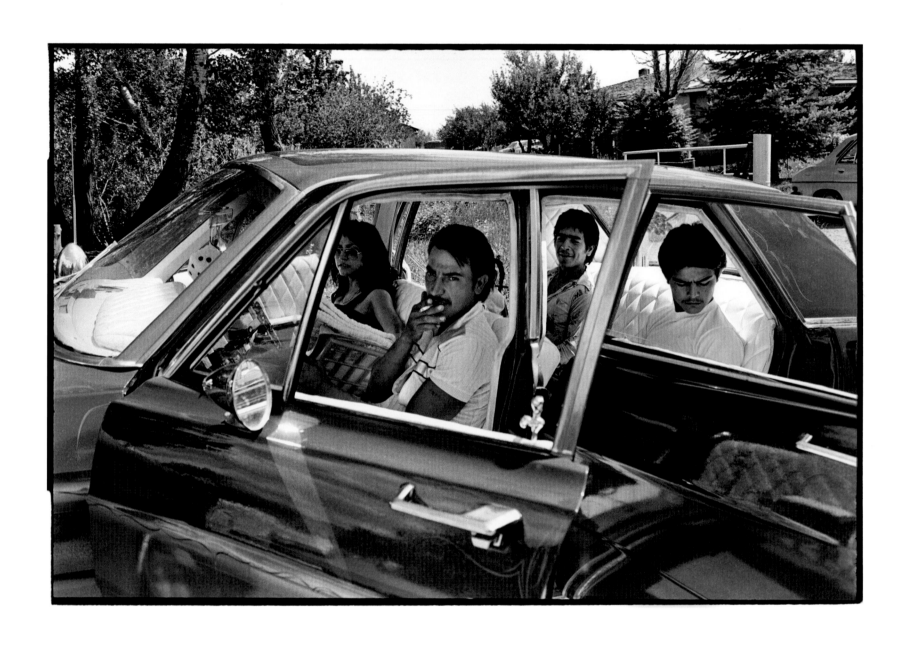

16. El Rito Fiesta Parade, 1981

right: 17. Father Blanc and Santiago, Chimayó Fiesta Parade, 1982

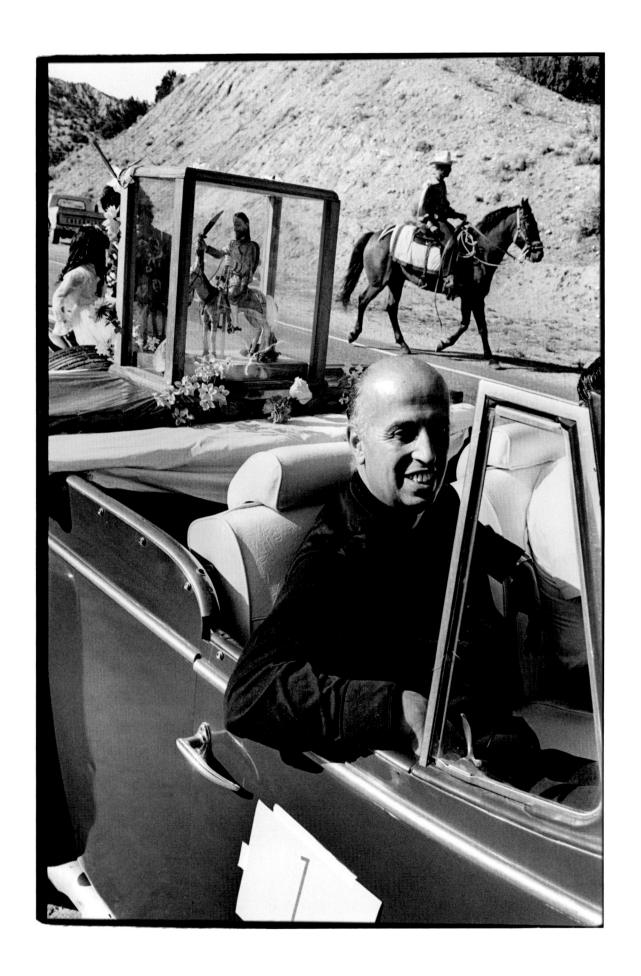

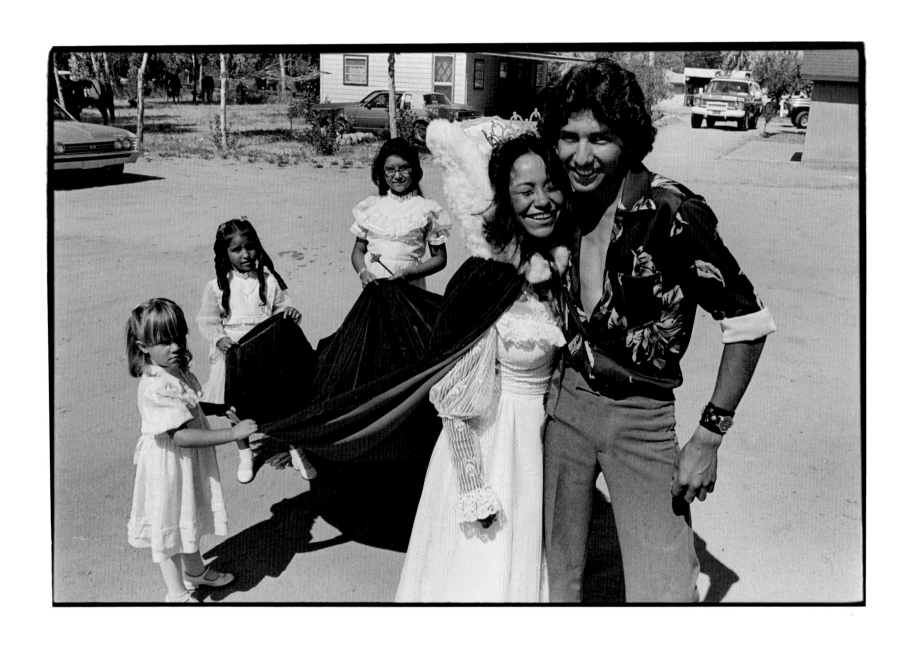

18. Chimayó Fiesta Queen, 1982

right: 19. Chimayó Fiesta Parade, 1982

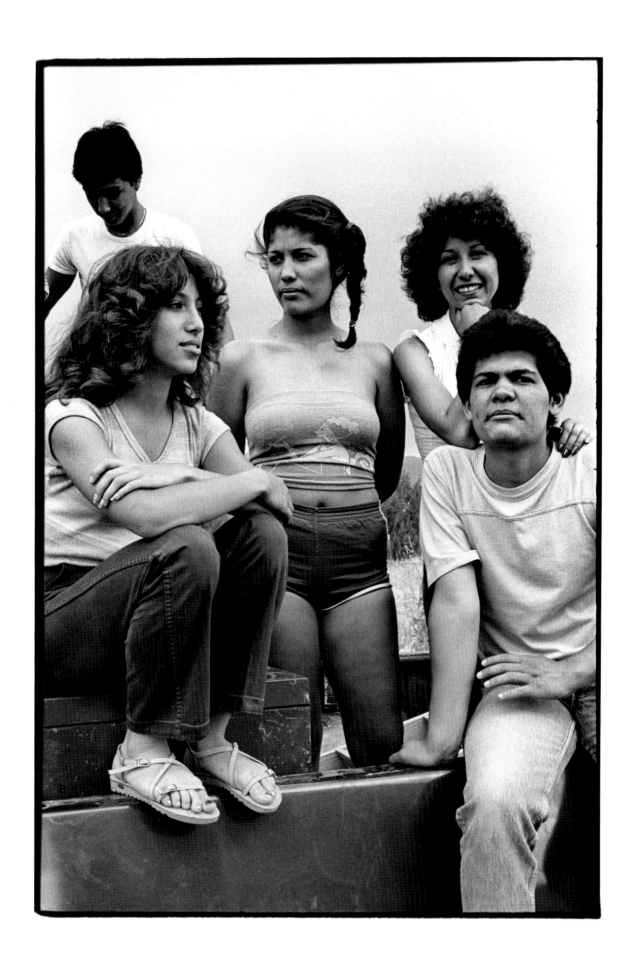

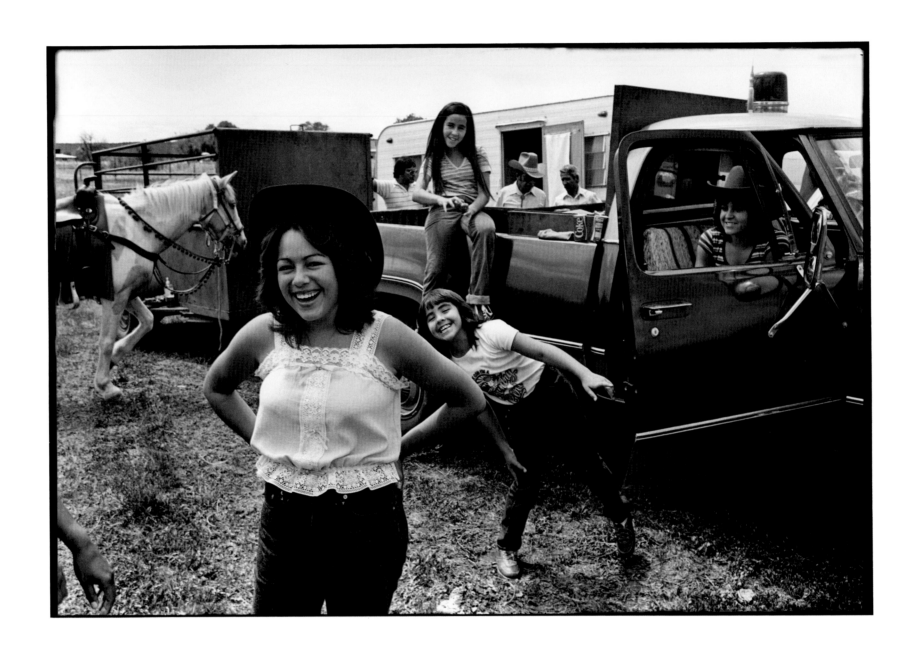

20. Luján Family, El Rito Fiesta, 1981

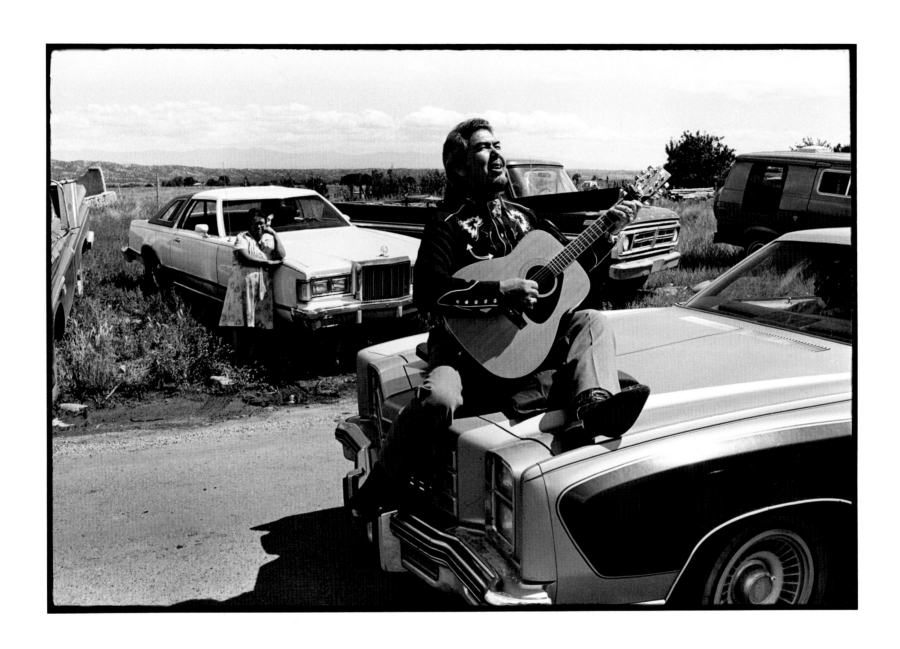

21. El Rito Fiesta, 1981

22. Chimayó Fiesta, 1982

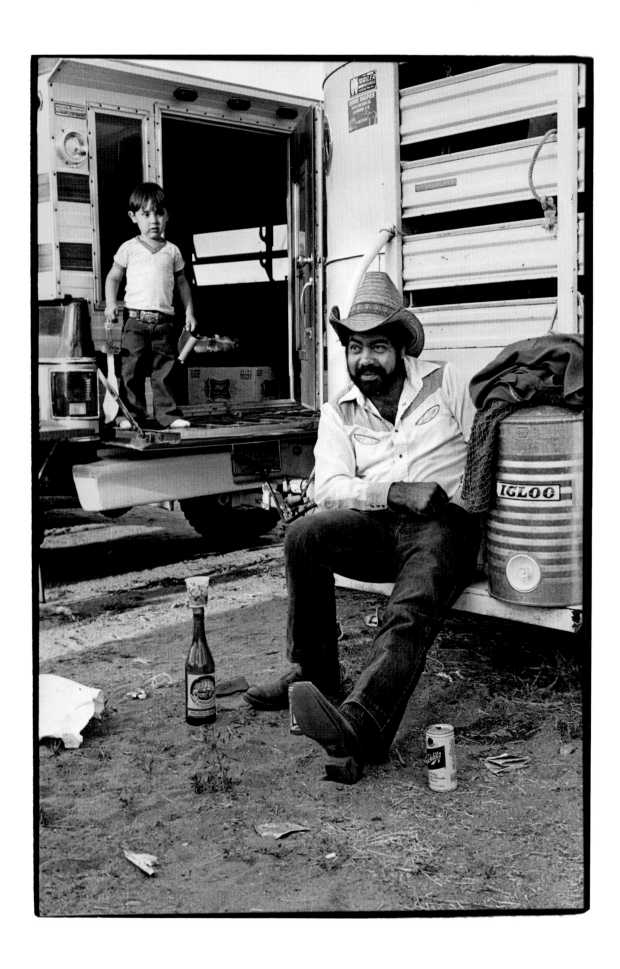

23. Good Friday, Chimayó, 1982

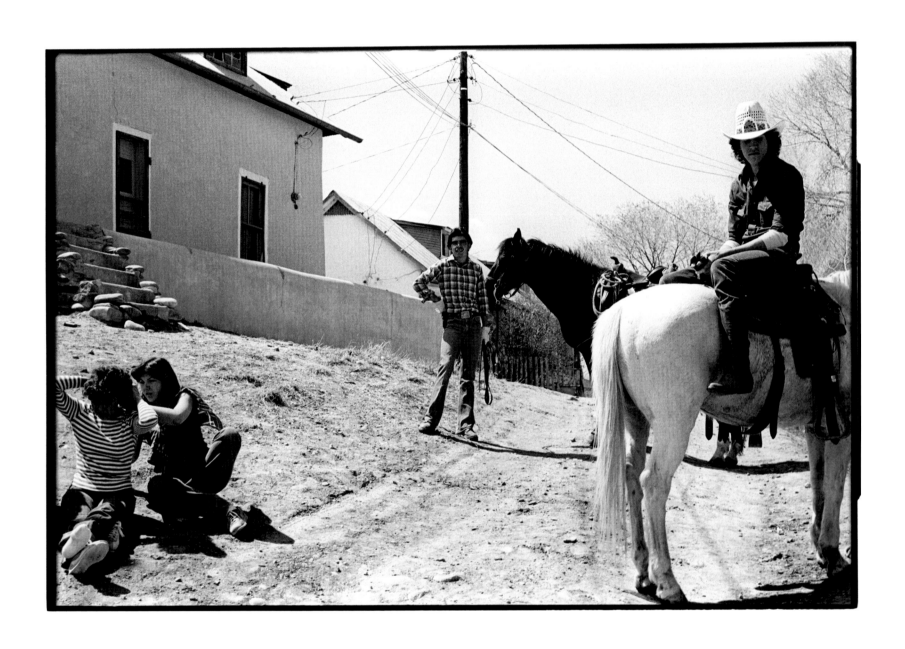

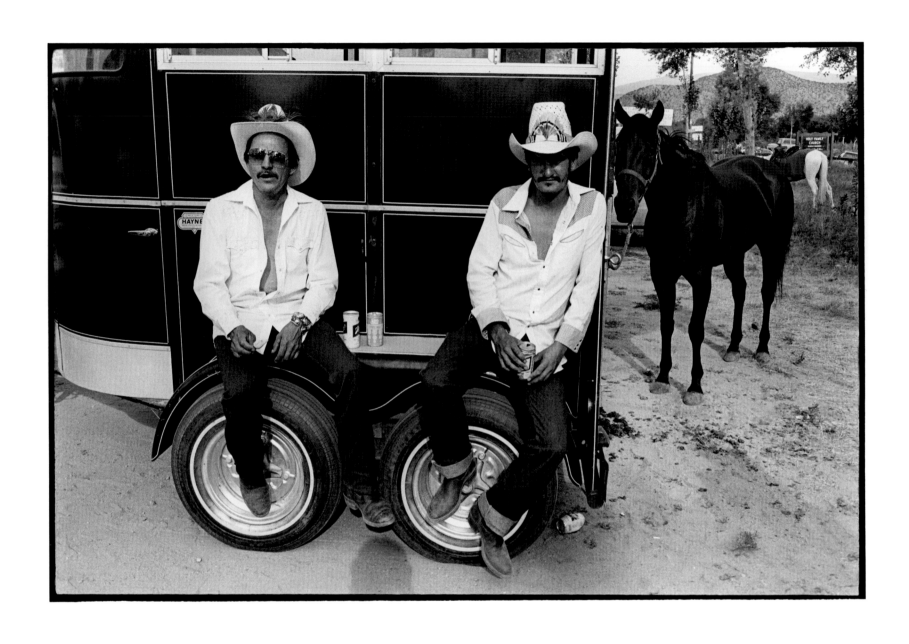

24. Chimayó Fiesta, 1982

right: 25. Chimayó Fiesta, 1982

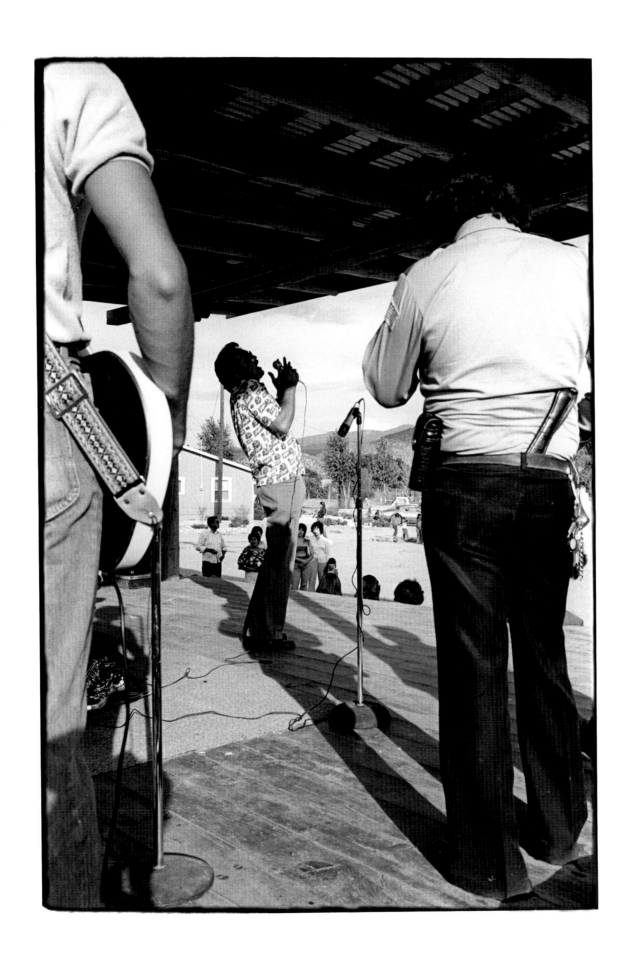

26. El Rito Fiesta, 1981

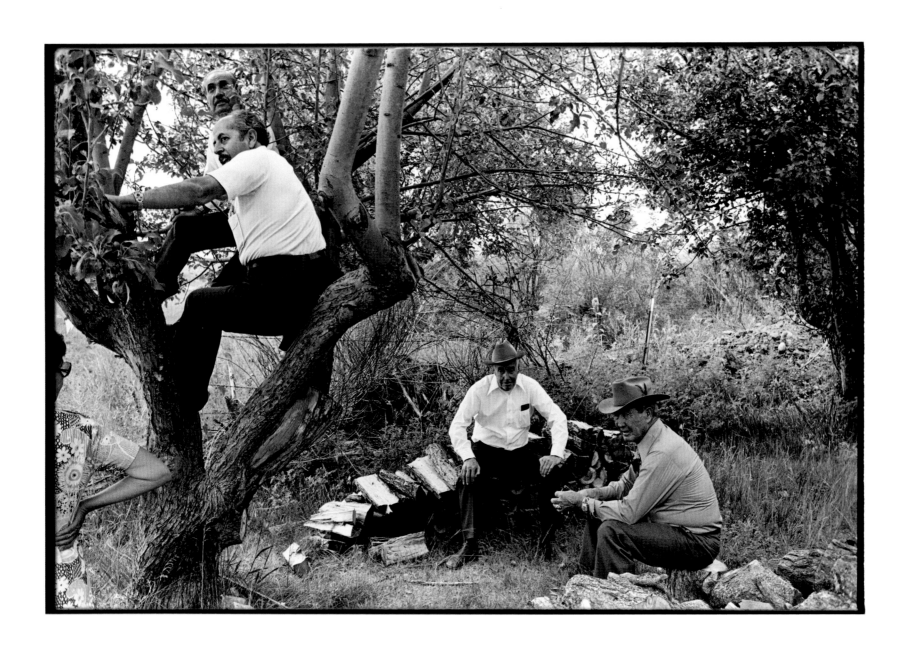

27. Chimayó Fiesta, 1982

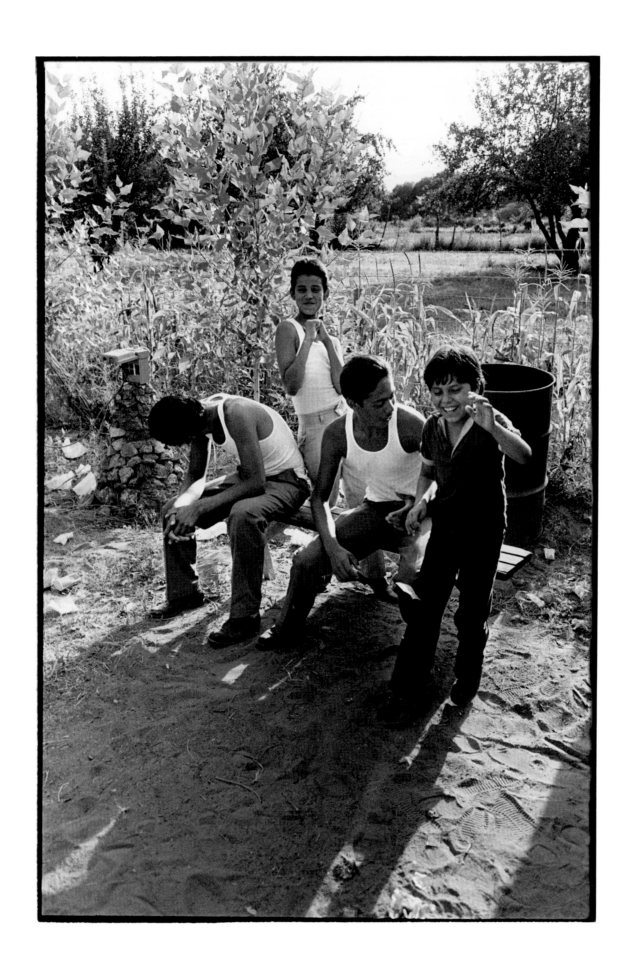

28. Wedding at Leopoldo's Lounge, Chimayó, 1982

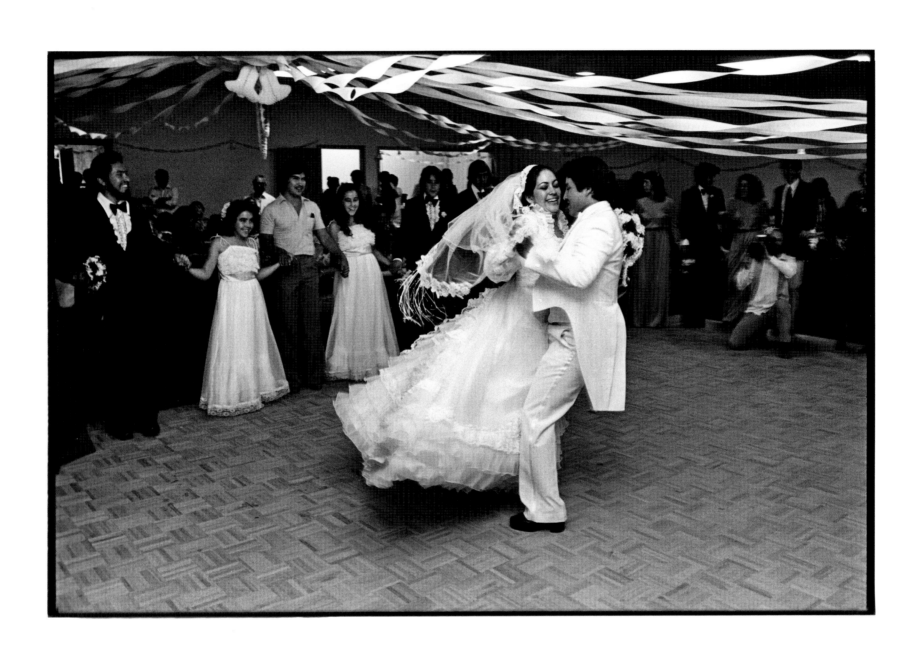

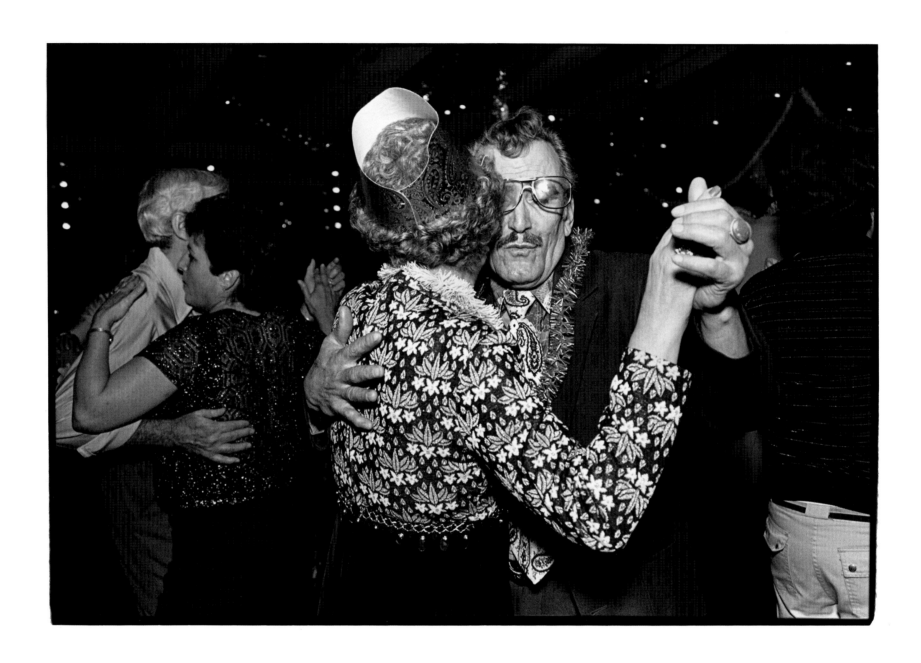

29. New Year's Eve, La Bamba Club, Albuquerque, 1983

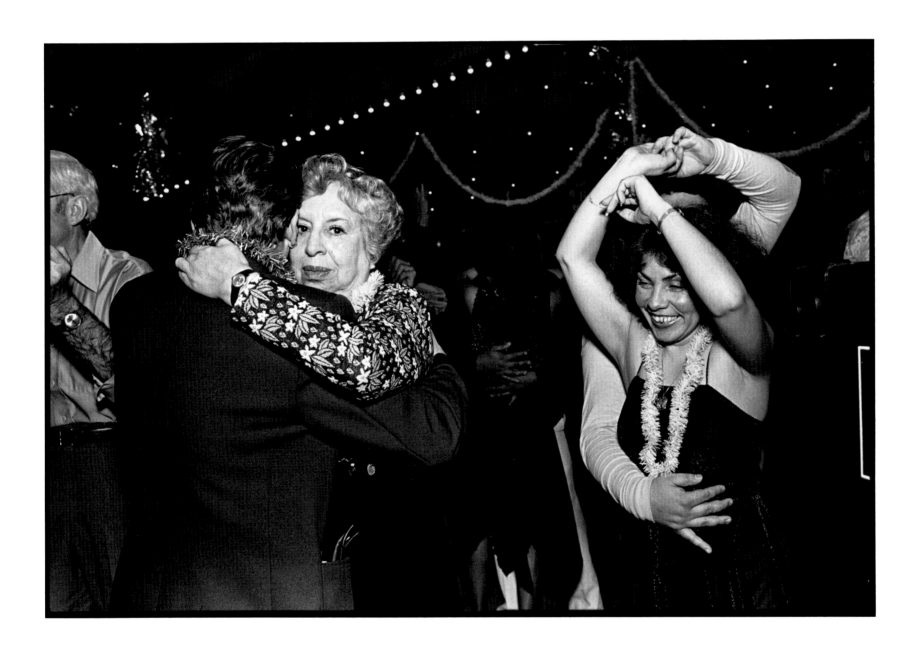

30. New Year's Eve, La Bamba Club, Albuquerque, 1983

31. New Year's Eve, La Bamba Club, Albuquerque, 1983

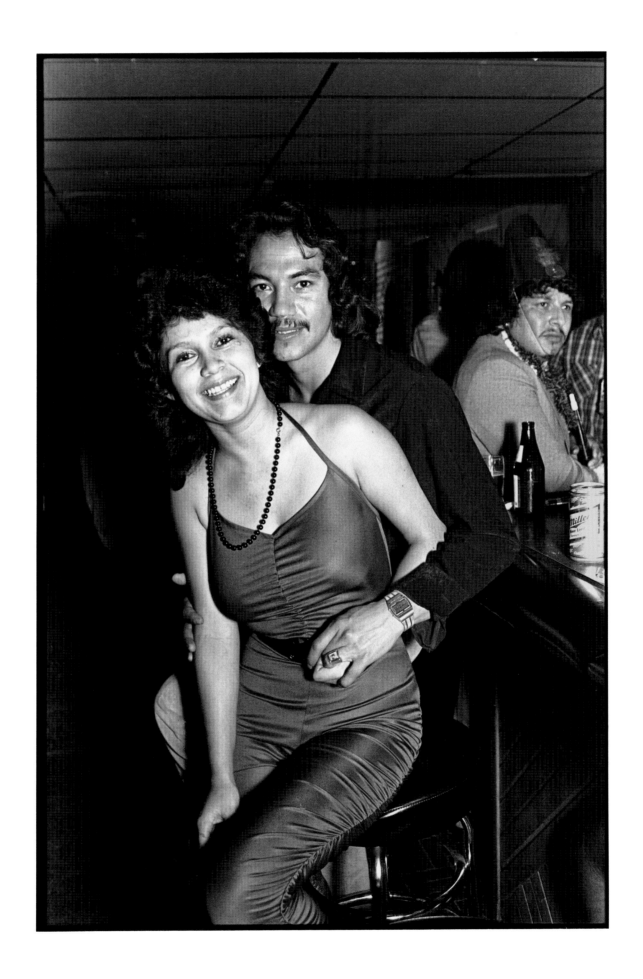

32. First Annual New Mexico Lowrider Car Show and Dance, Albuquerque, 1983

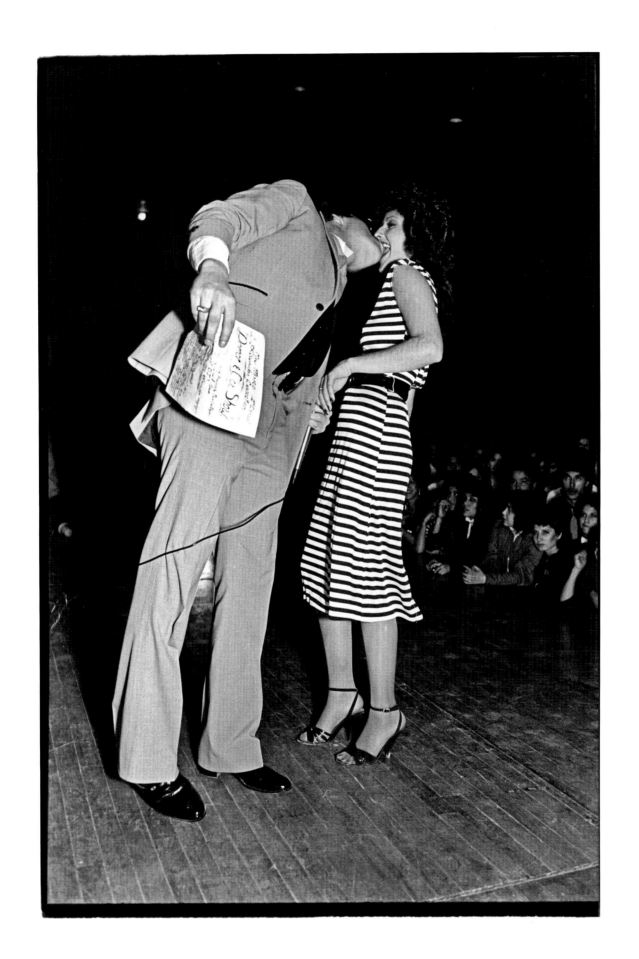

33. New Mexico State Fair, Albuquerque, 1982

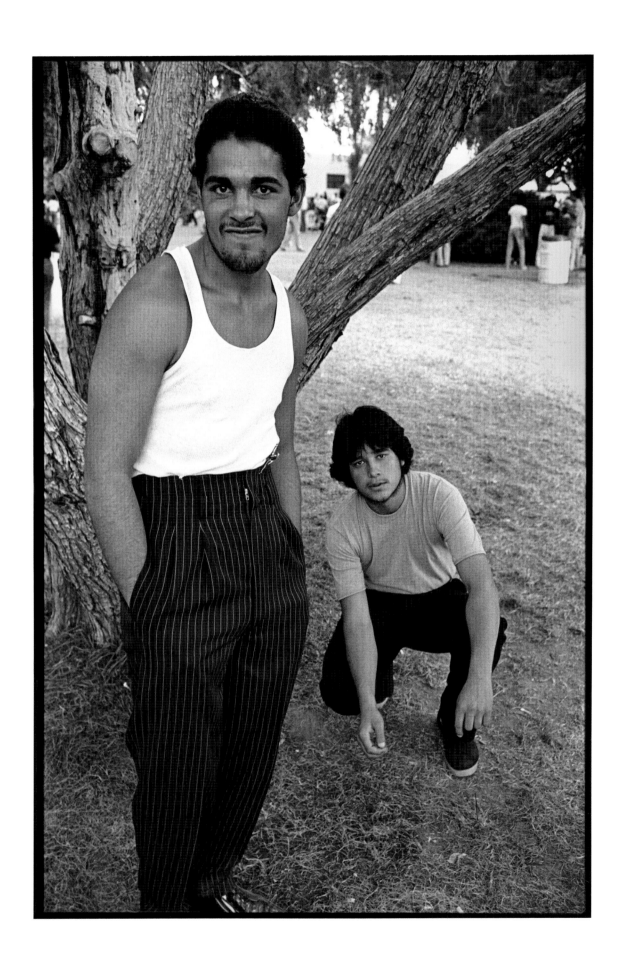

34. Santa Fe Carnival, 1982

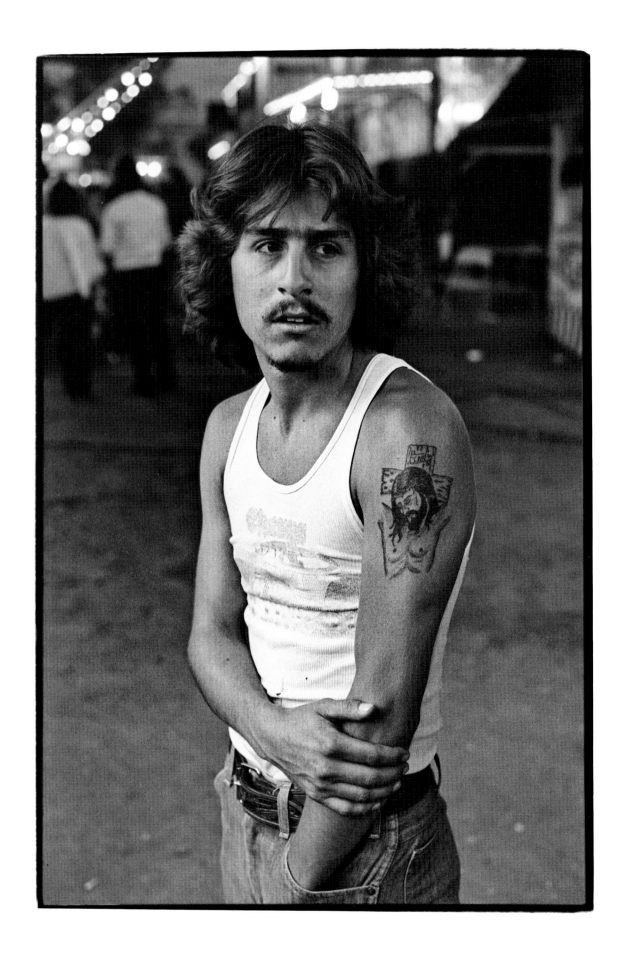

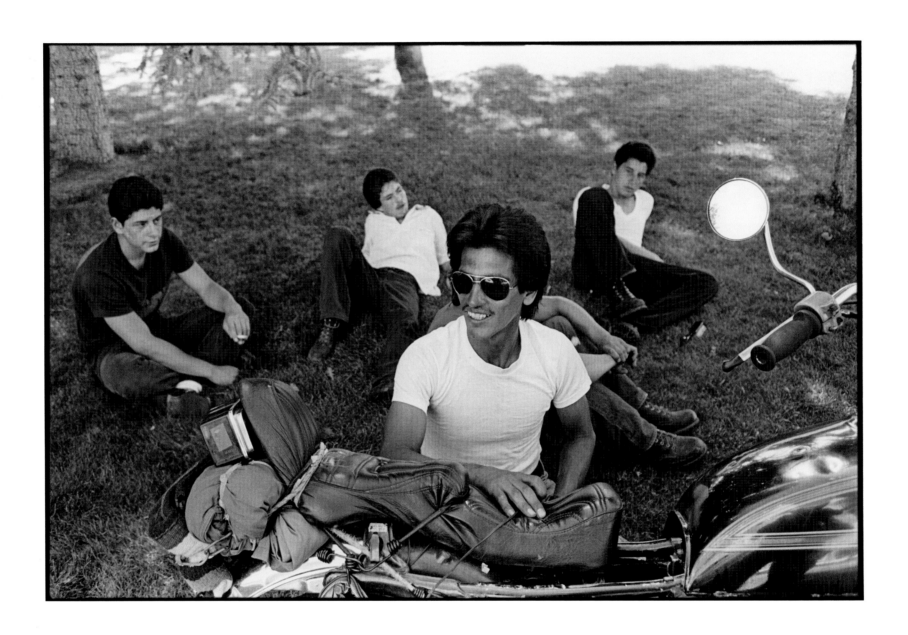

35. Riverside Park Brothers, Santa Fe, 1982

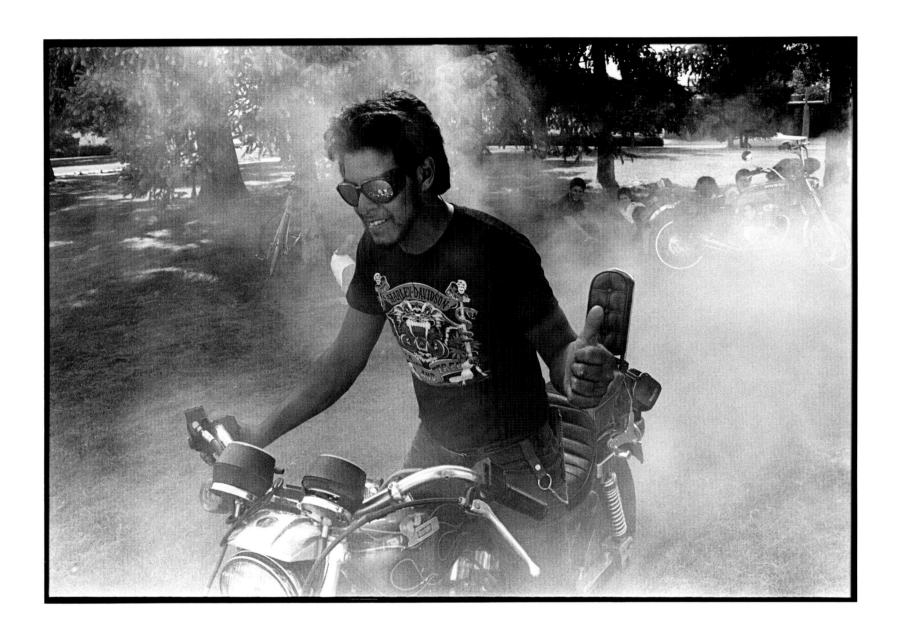

36. Riverside Park Brothers, Santa Fe, 1982

37. San Juan Carnival, 1982

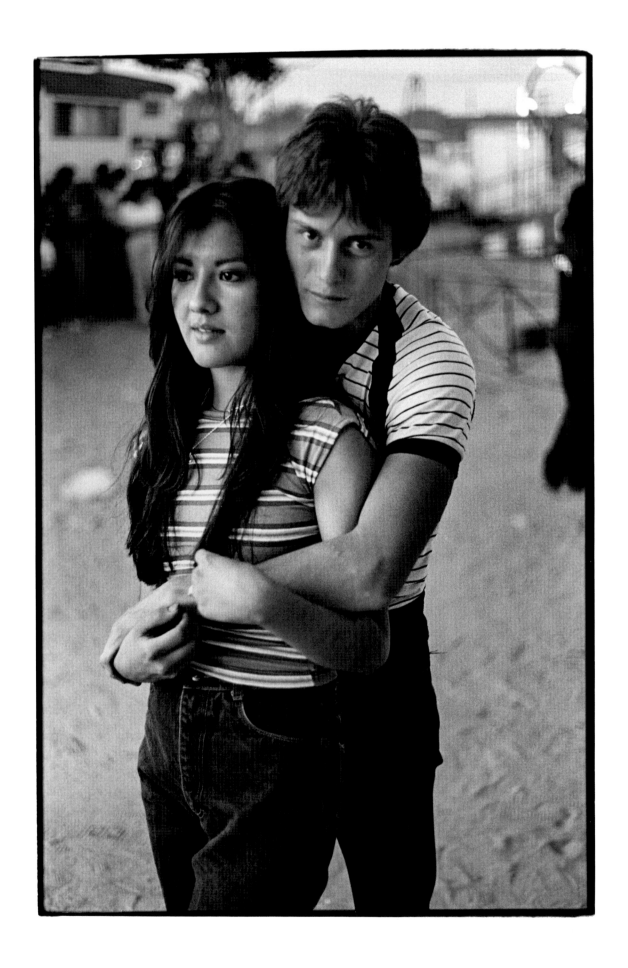

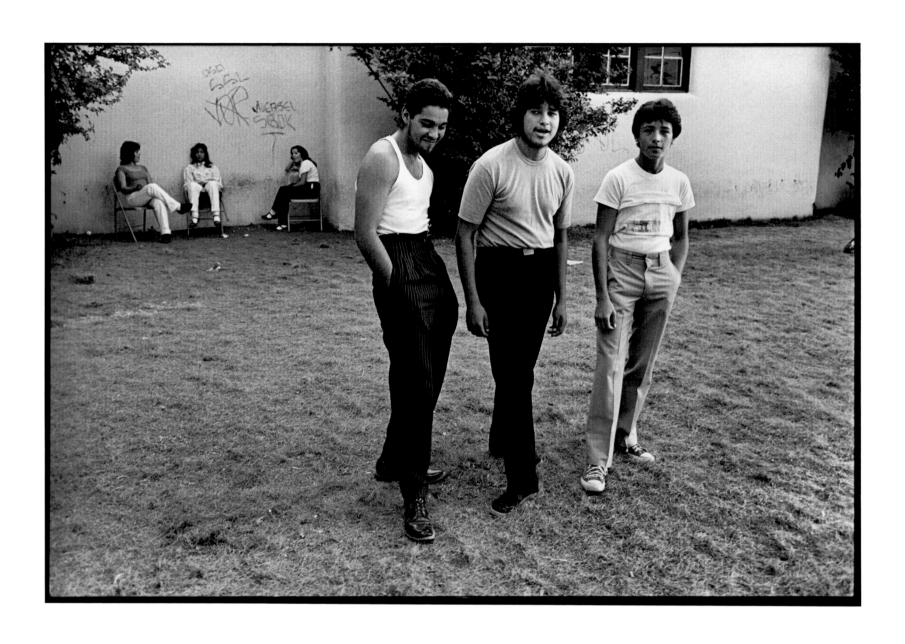

38. New Mexico State Fair, Albuquerque, 1982

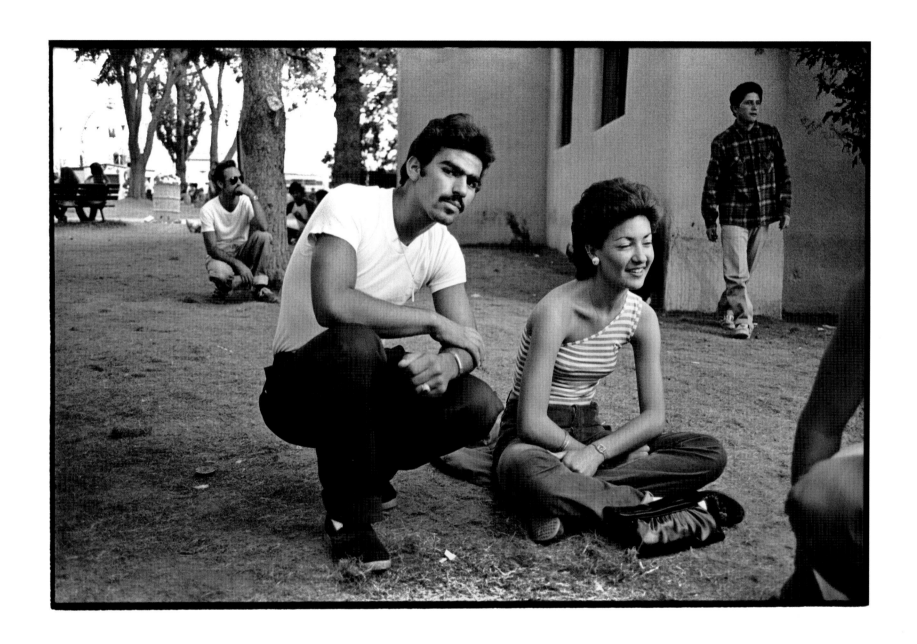

39. New Mexico State Fair, Albuquerque, 1982

40. New Mexico State Fair, Albuquerque, 1982

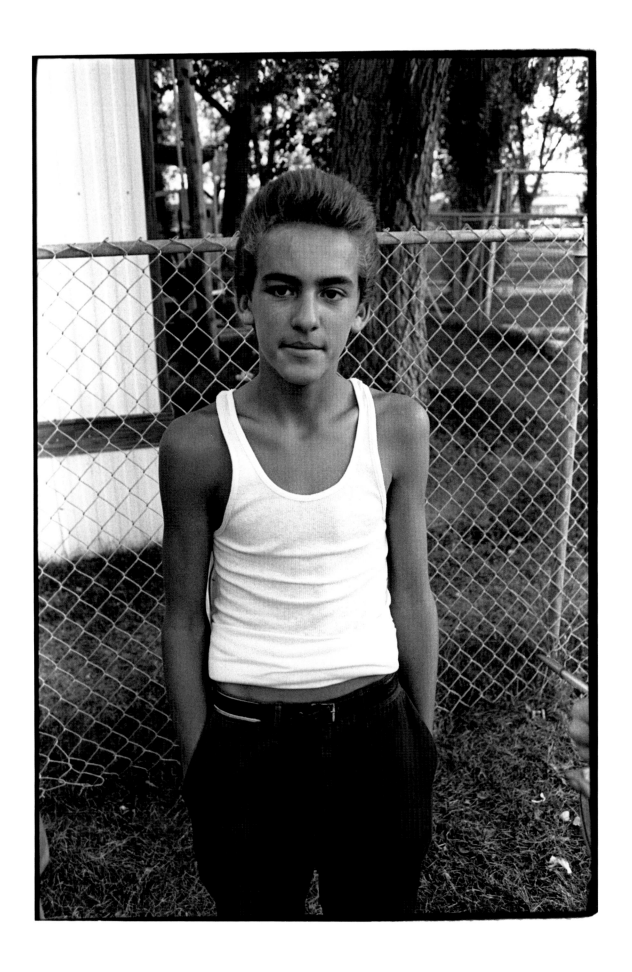

41. New Mexico State Fair, Albuquerque, 1982

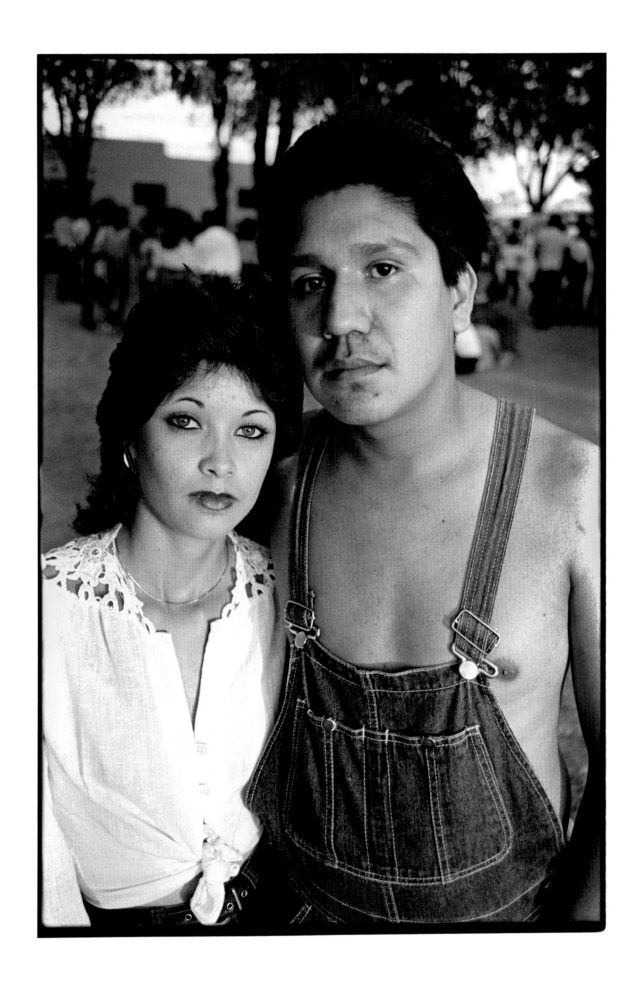

42. New Mexico State Fair, Albuquerque, 1982

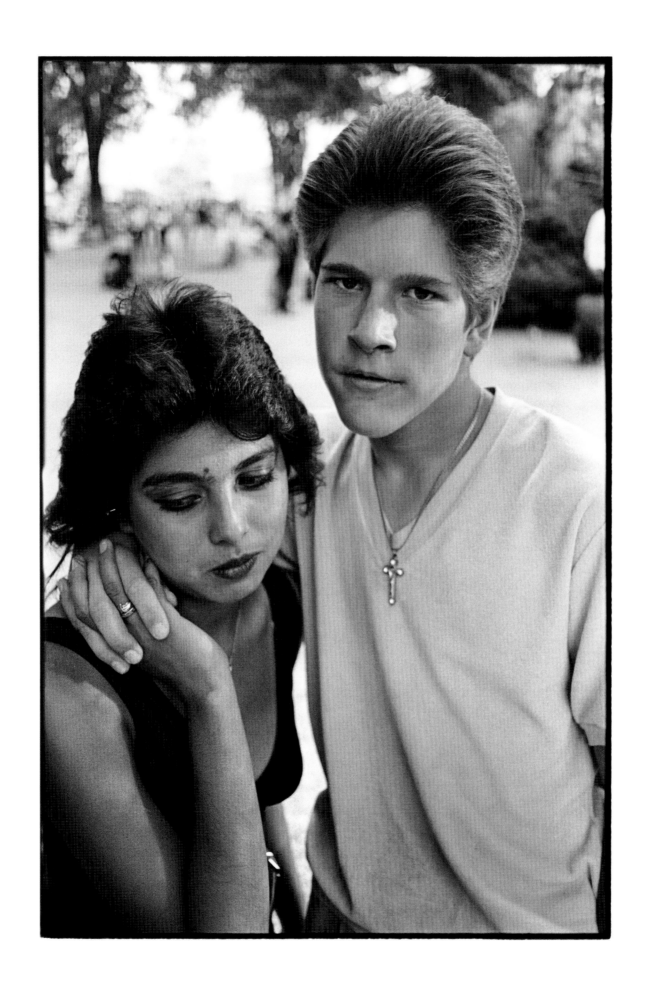

43. New Mexico State Fair, Albuquerque, 1982

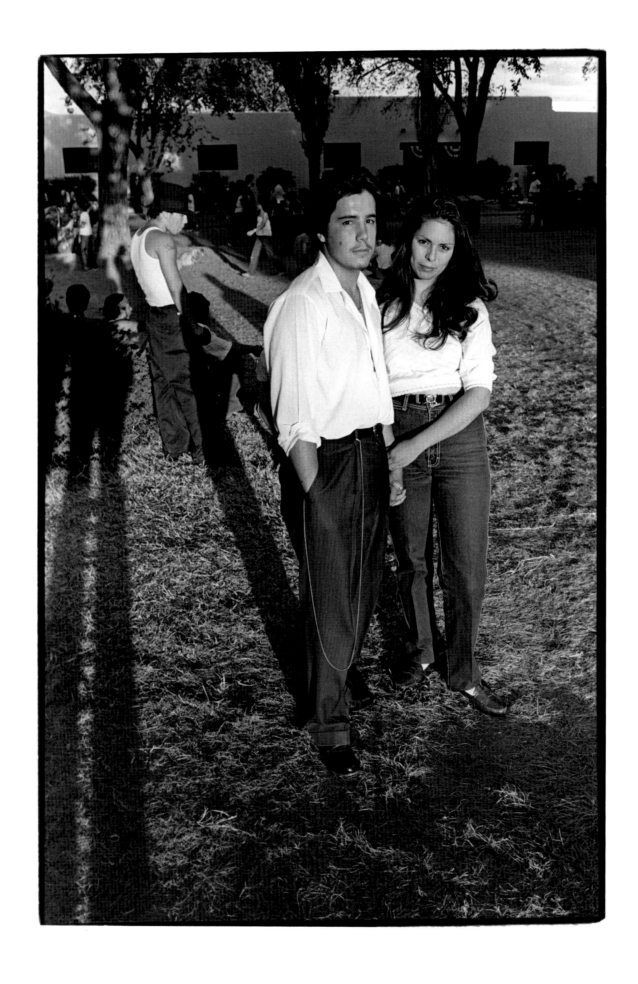

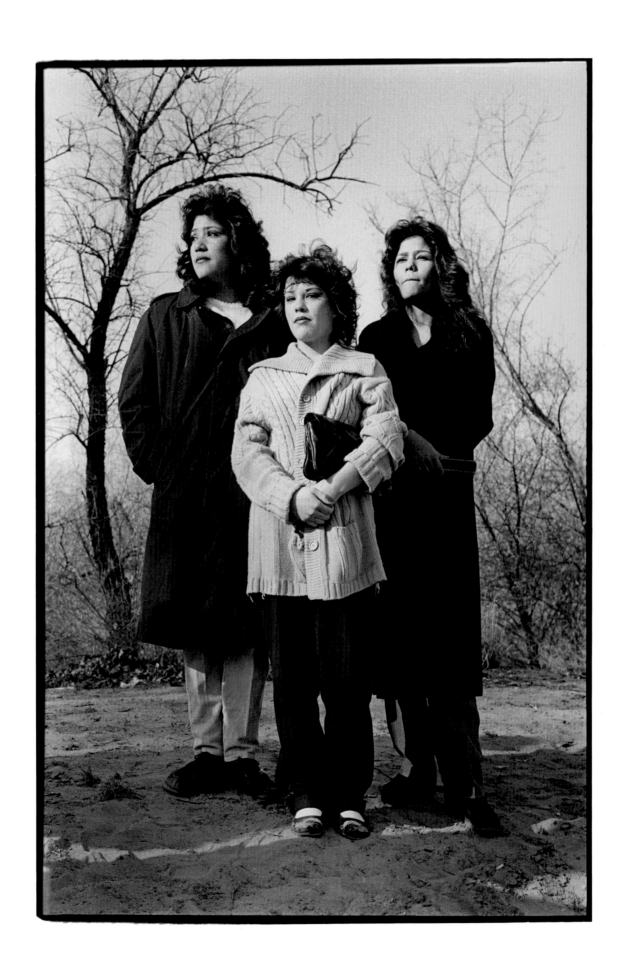

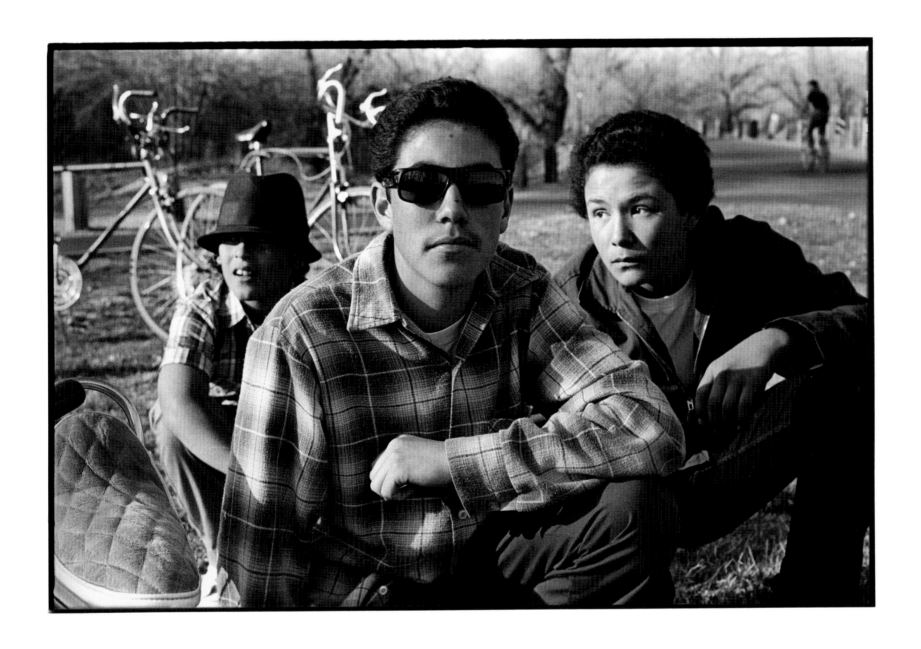

44. San Gabriel Park, Albuquerque, 1983

left: 45. San Gabriel Park, Albuquerque, 1983

46. San Gabriel Park, Albuquerque, 1983

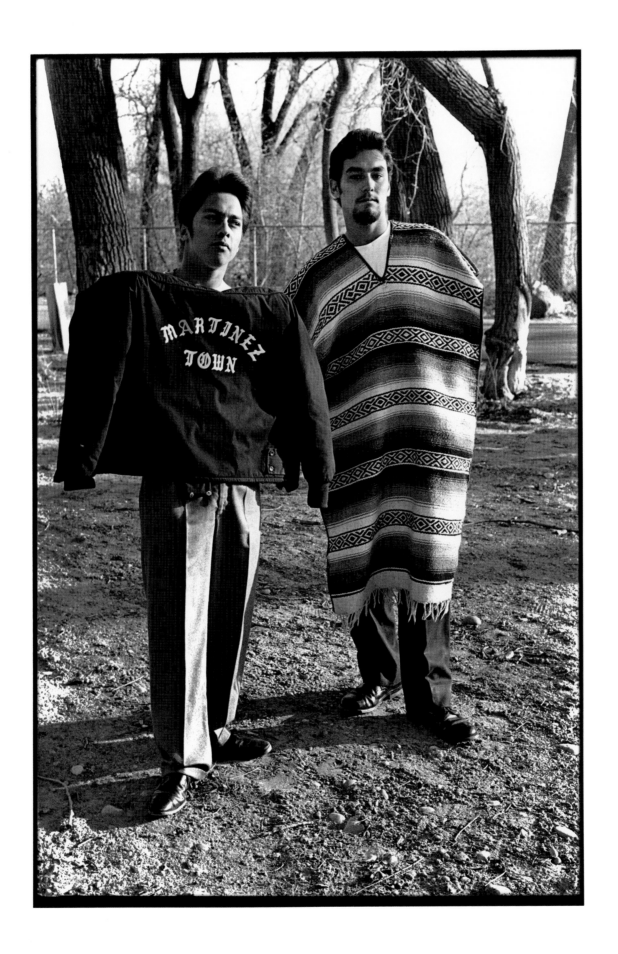

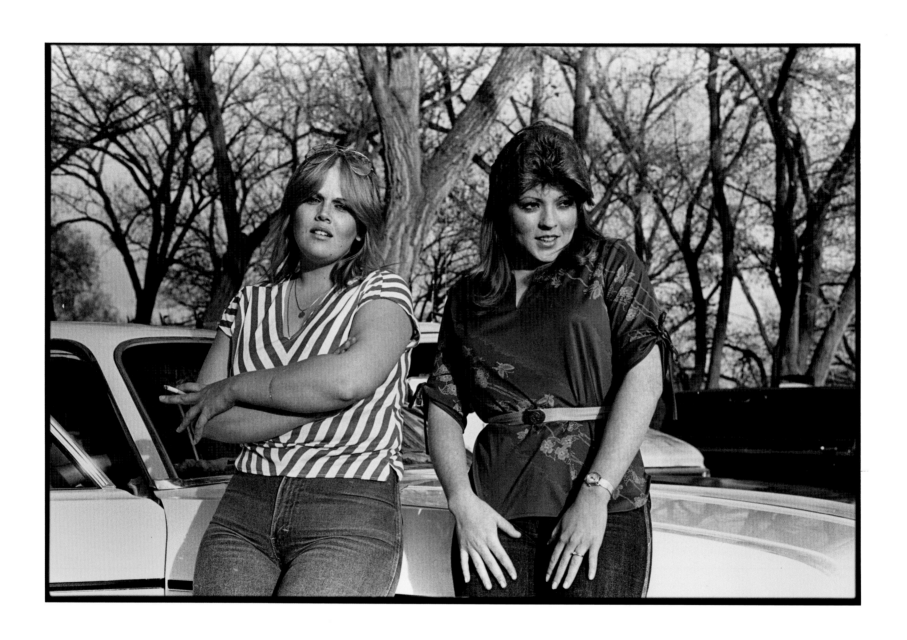

47. San Gabriel Park, Albuquerque, 1983

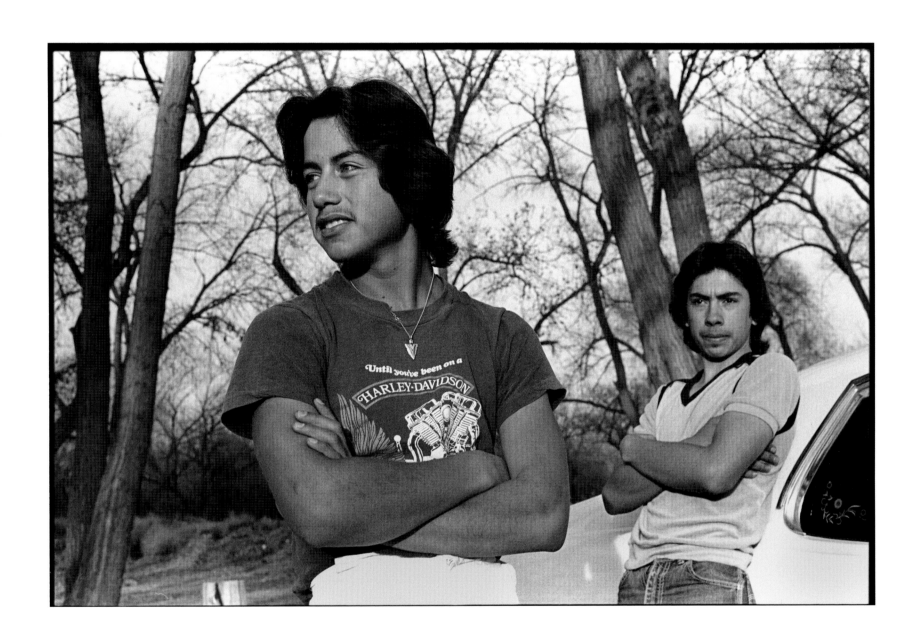

48. San Gabriel Park, Albuquerque, 1983

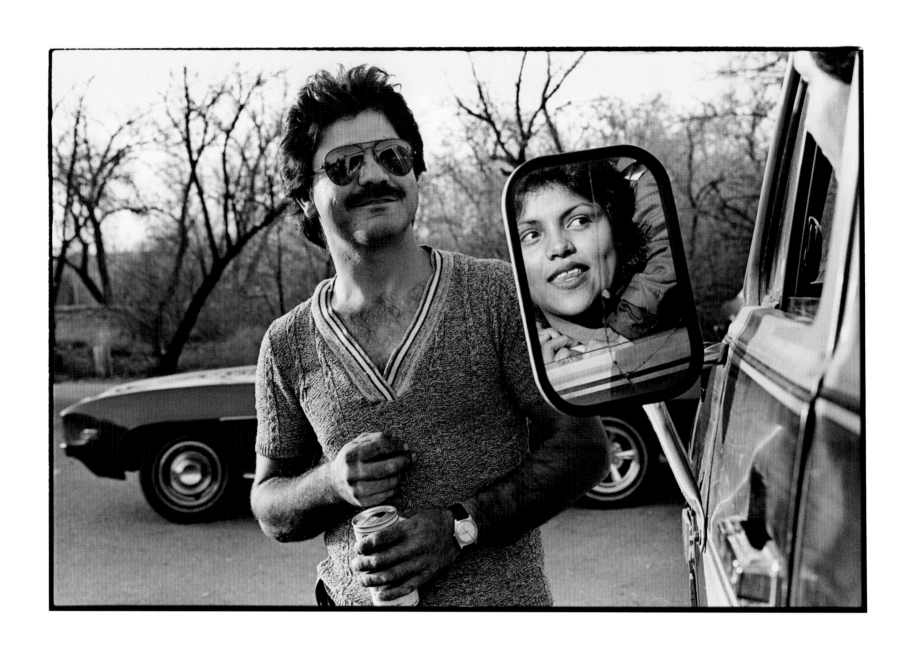

49. San Gabriel Park, Albuquerque, 1983

right: 50. San Gabriel Park, Albuquerque, 1983

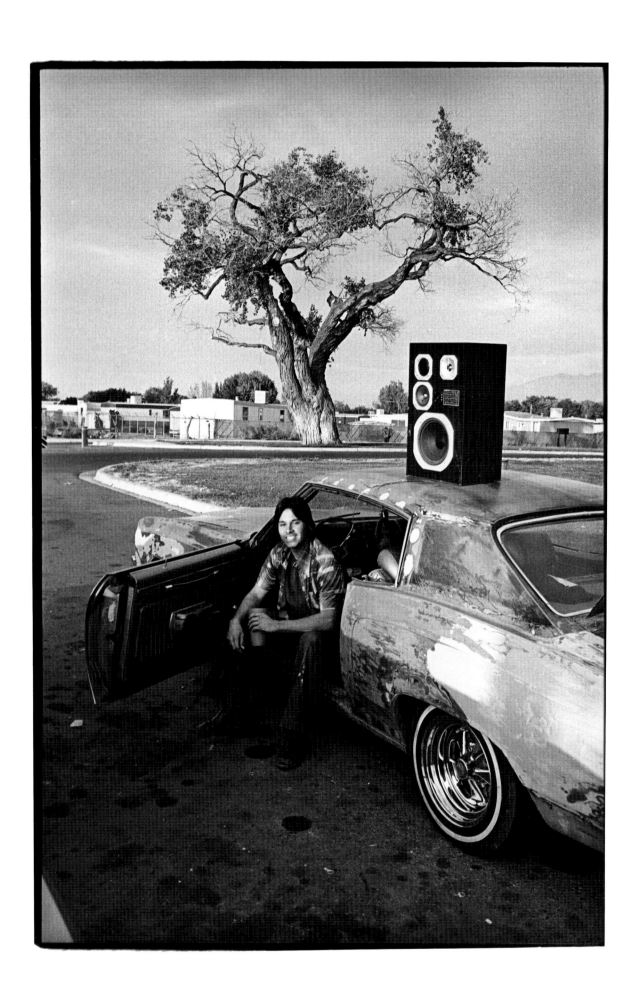

51. San Gabriel Park, Albuquerque, 1983

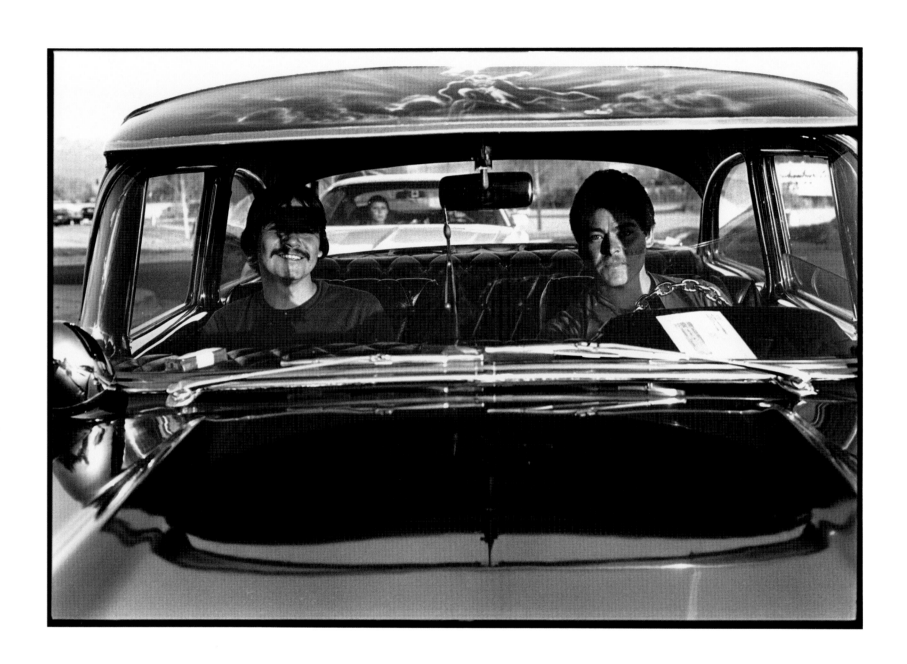

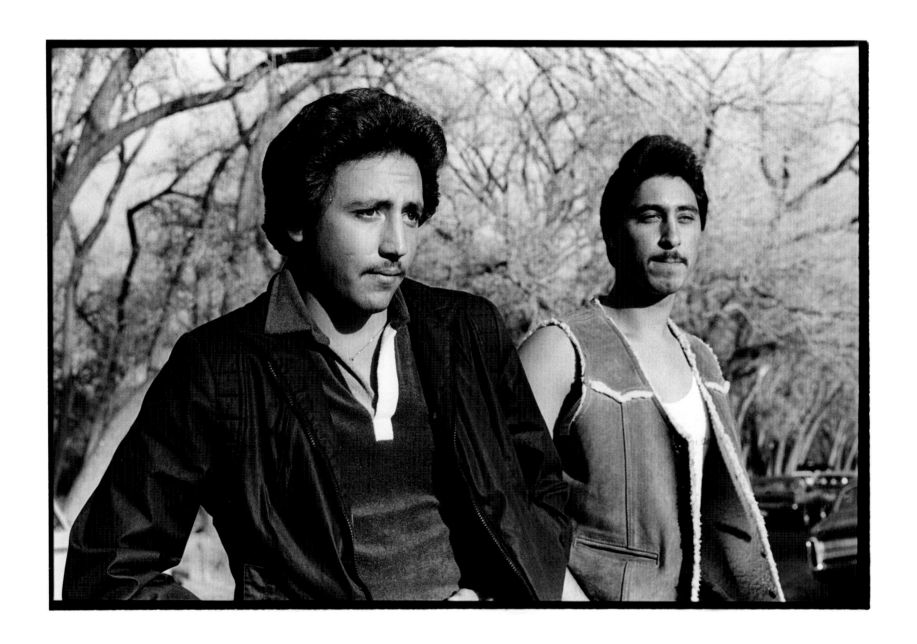

52. San Gabriel Park, Albuquerque, 1983

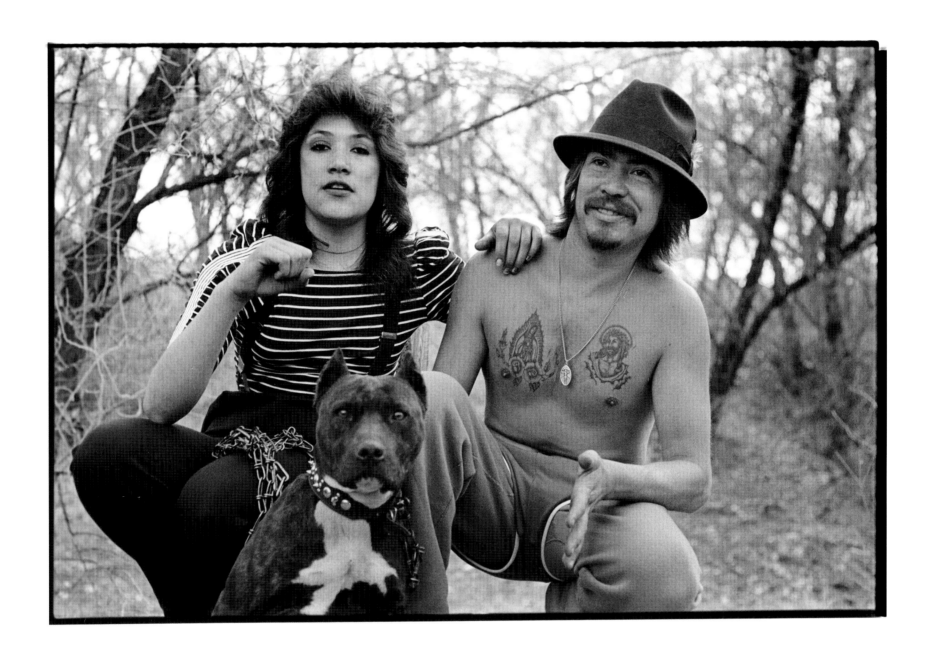

53. San Gabriel Park, Albuquerque, 1983

54. San Gabriel Park, Albuquerque, 1983

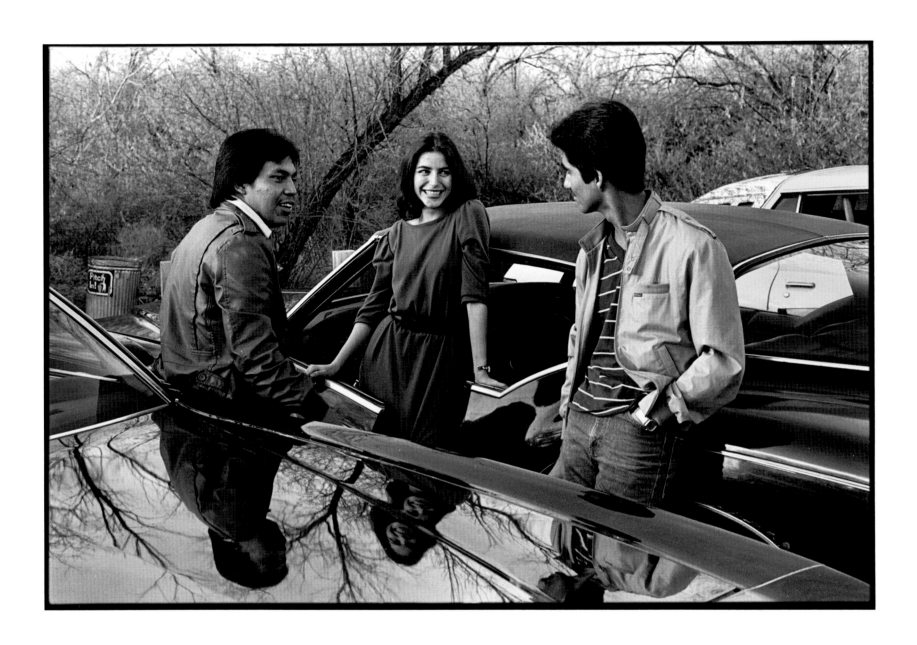

55. San Gabriel Park, Albuquerque, 1983

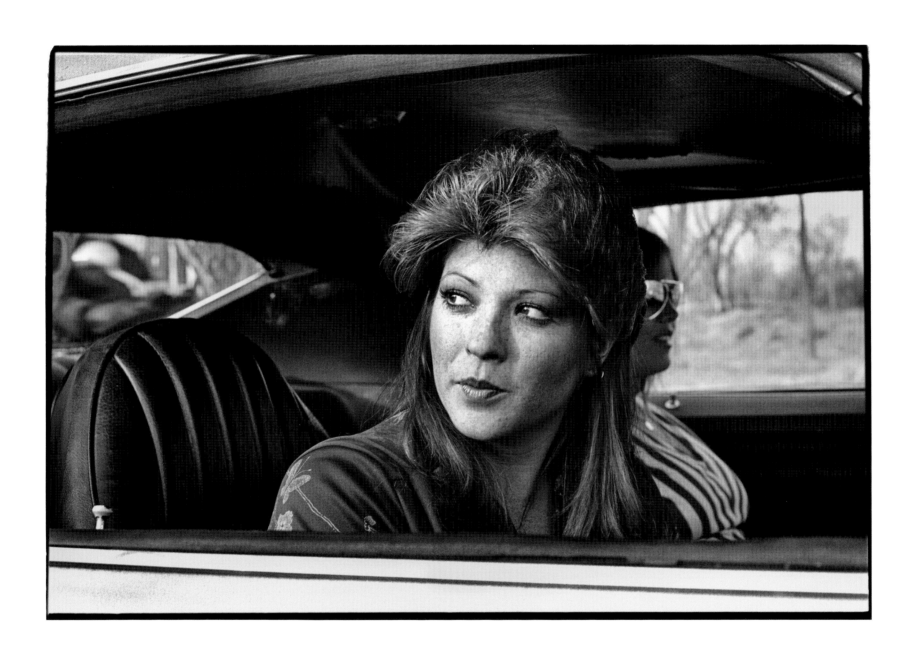

56. San Gabriel Park, Albuquerque, 1983

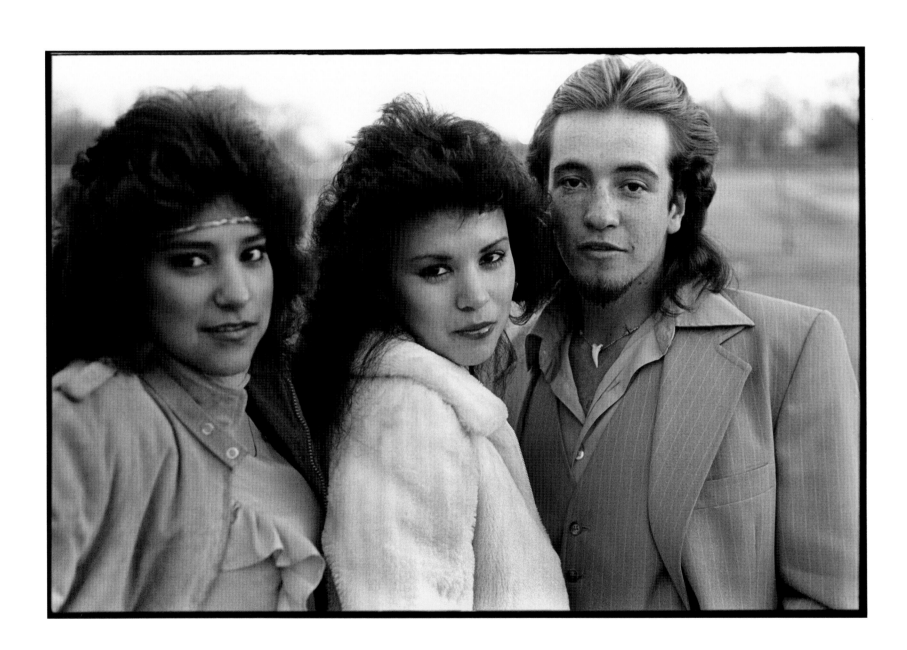

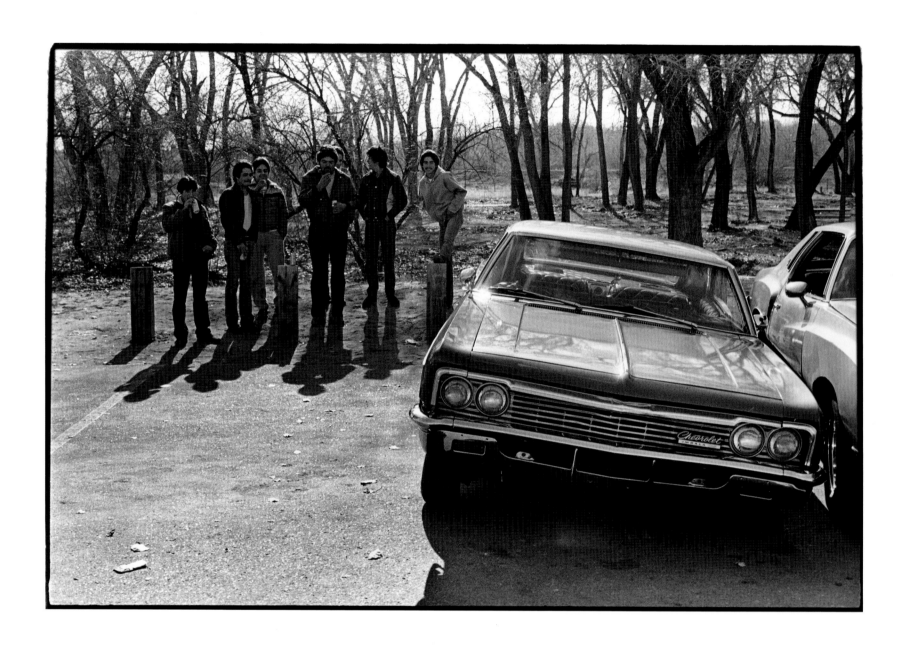

57. San Gabriel Park, Albuquerque, 1983

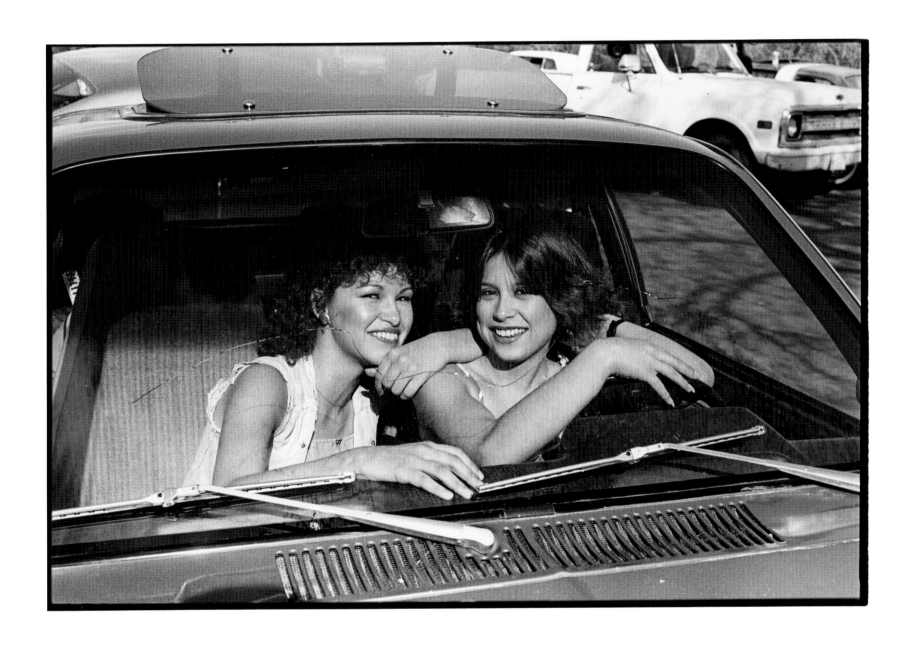

58. San Gabriel Park, Albuquerque, 1983

59. San Gabriel Park, Albuquerque, 1983

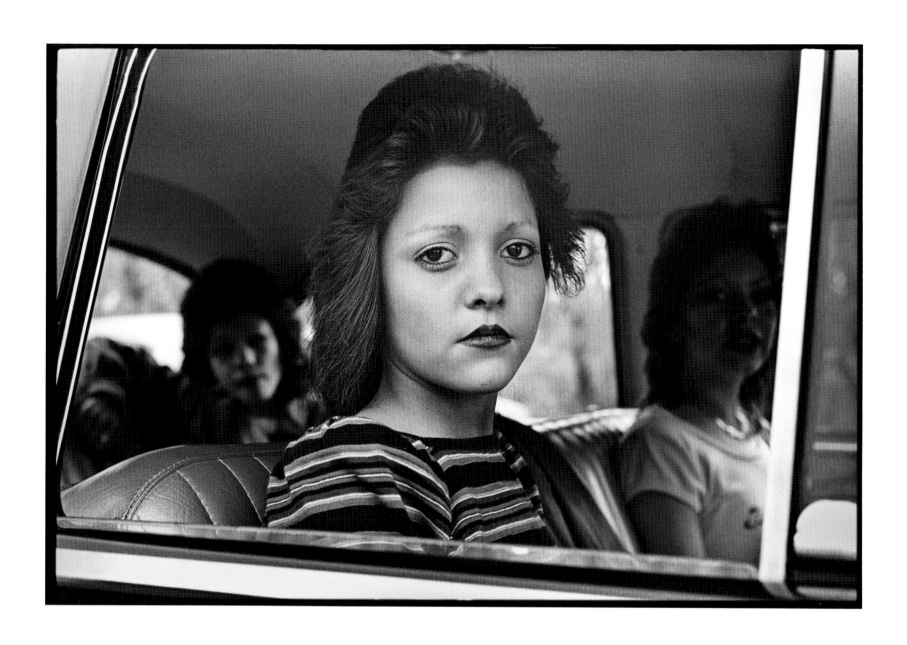

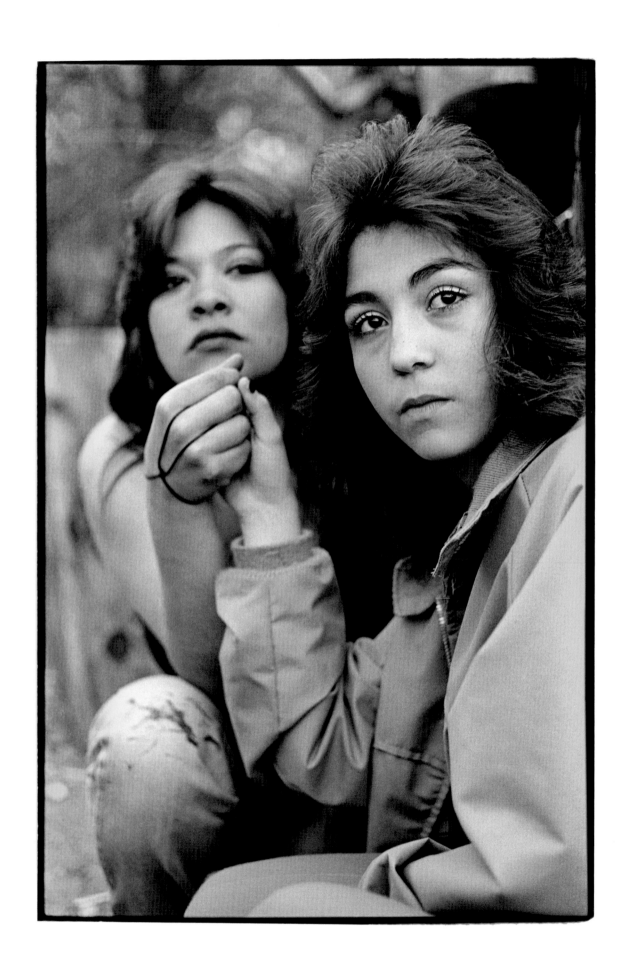

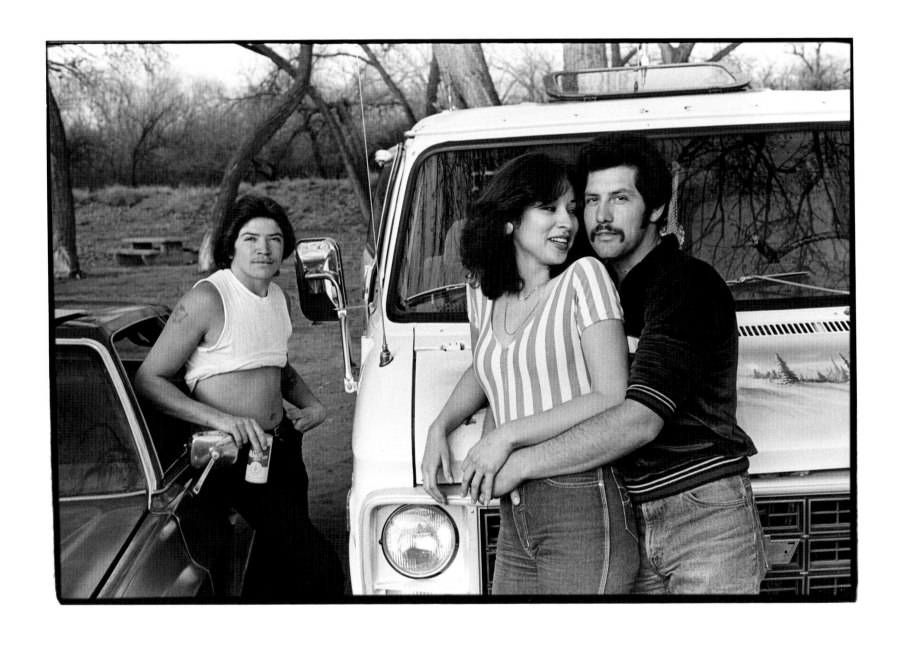

60. San Gabriel Park, Albuquerque, 1983

left: 61. San Gabriel Park, Albuquerque, 1983

62. San Gabriel Park, Albuquerque, 1983

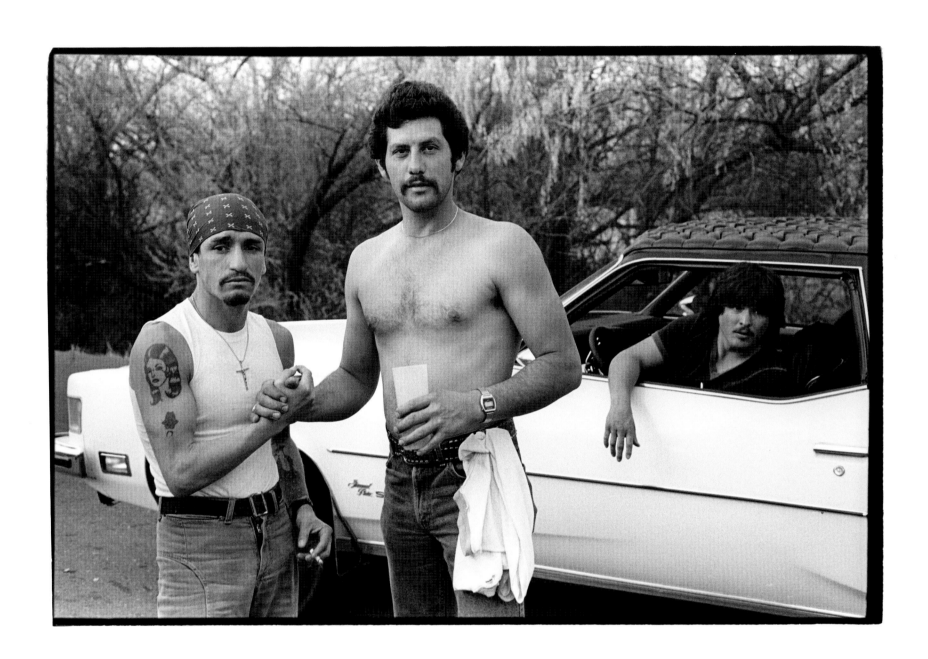

63. San Gabriel Park, Albuquerque, 1983

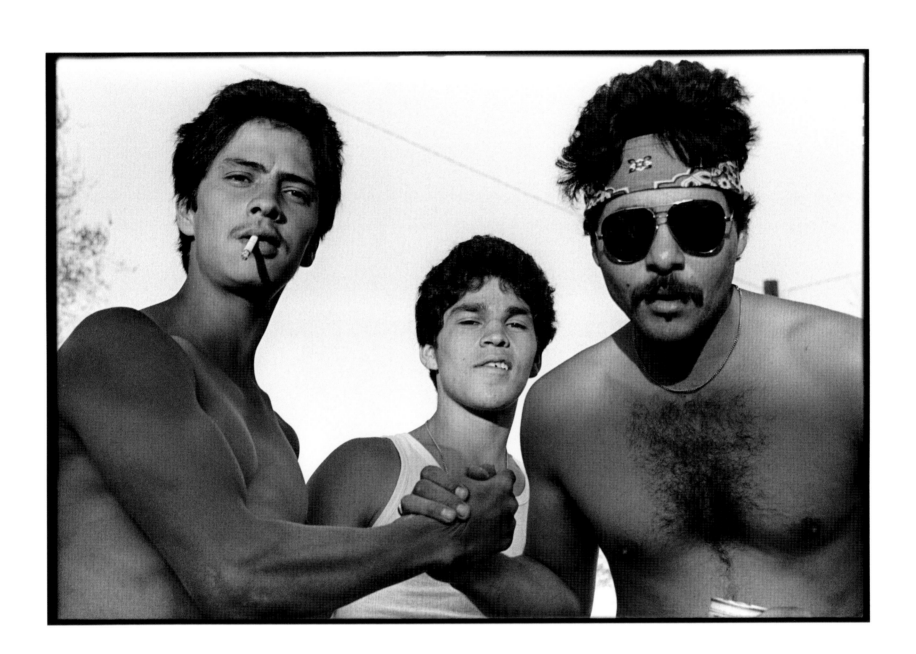

64. San Gabriel Park, Albuquerque, 1983

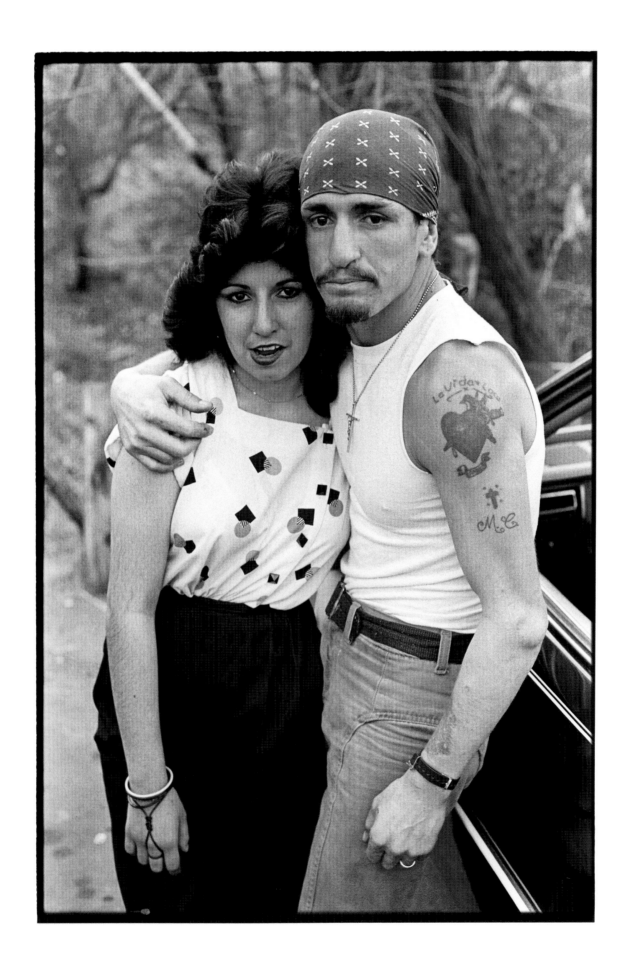

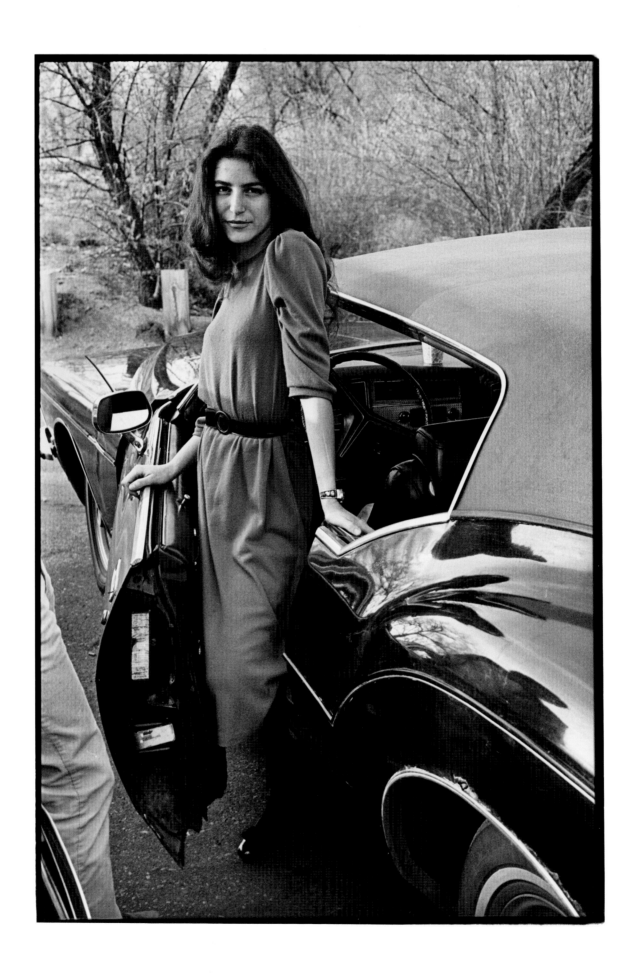

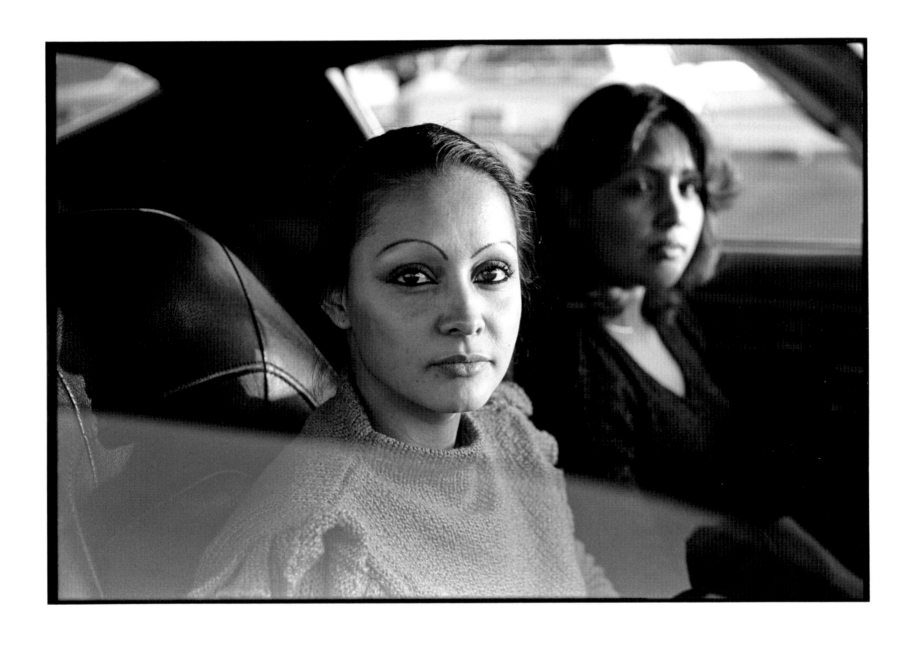

65. San Gabriel Park, Albuquerque, 1983

left: 66. San Gabriel Park, Albuquerque, 1983

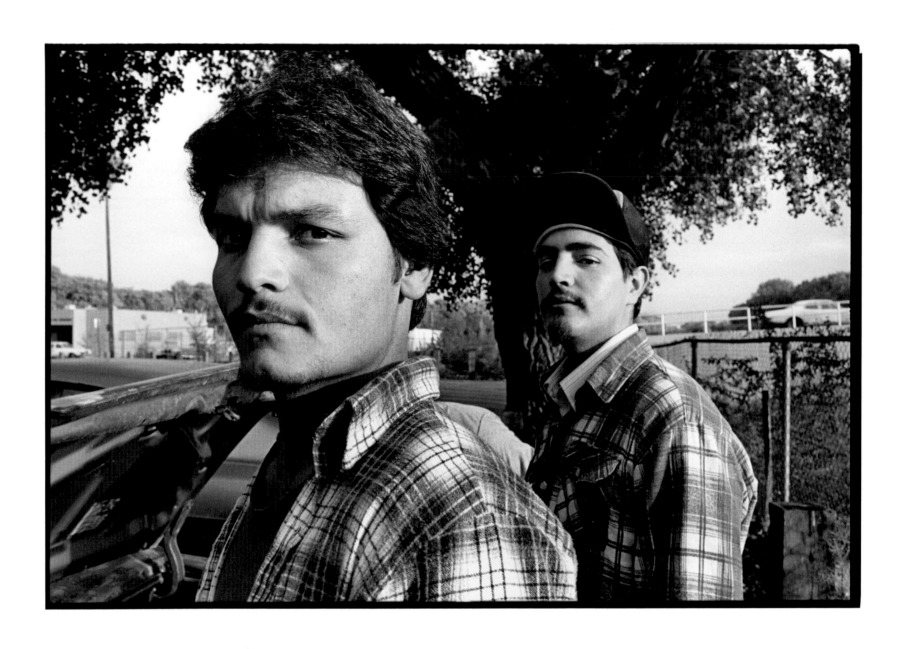

67. San Gabriel Park, Albuquerque, 1983

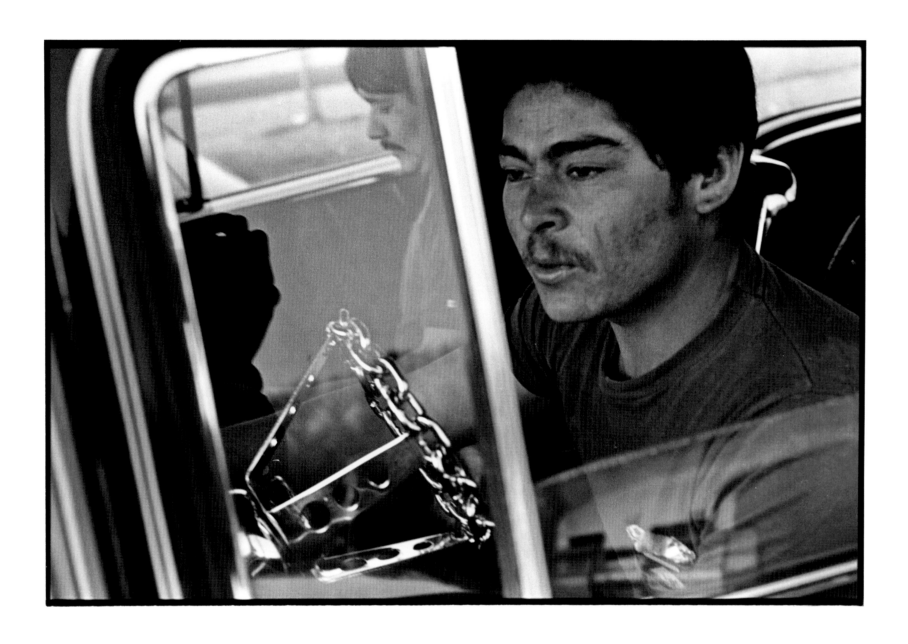

68. San Gabriel Park, Albuquerque, 1983

69. San Gabriel Park, Albuquerque, 1983

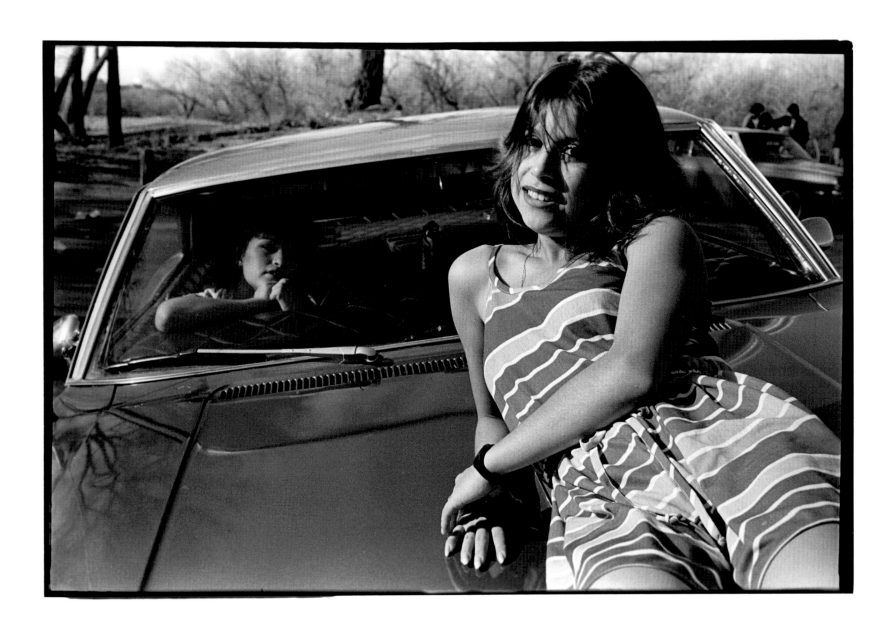

70. San Gabriel Park, Albuquerque, 1983

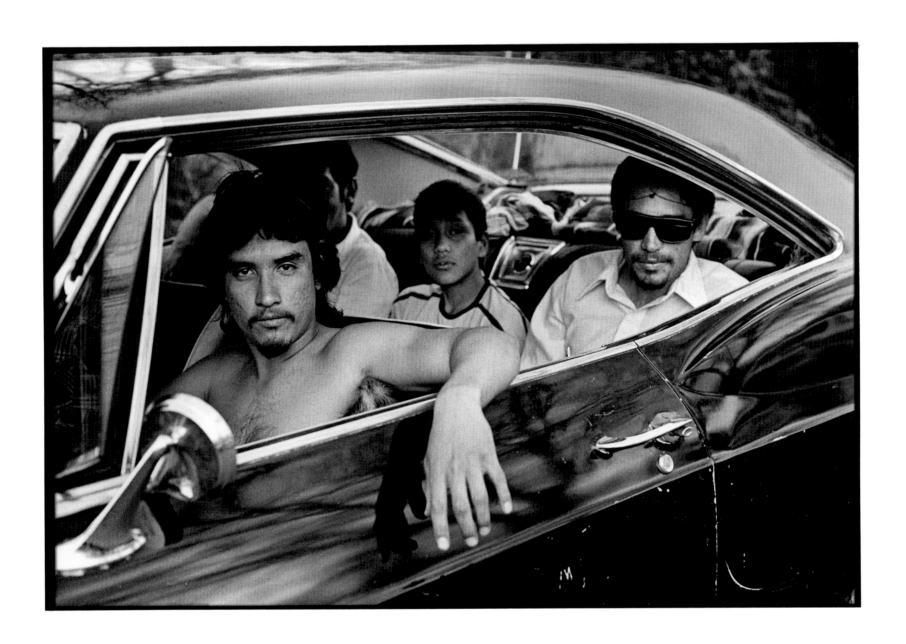

71. Española Valley High School, 1983

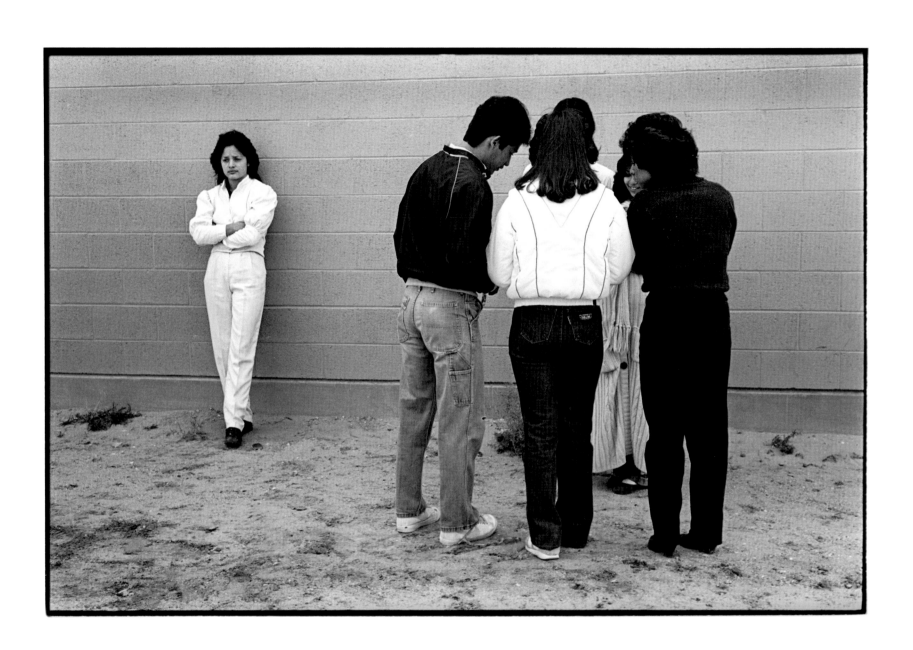

72. Albuquerque, 1982

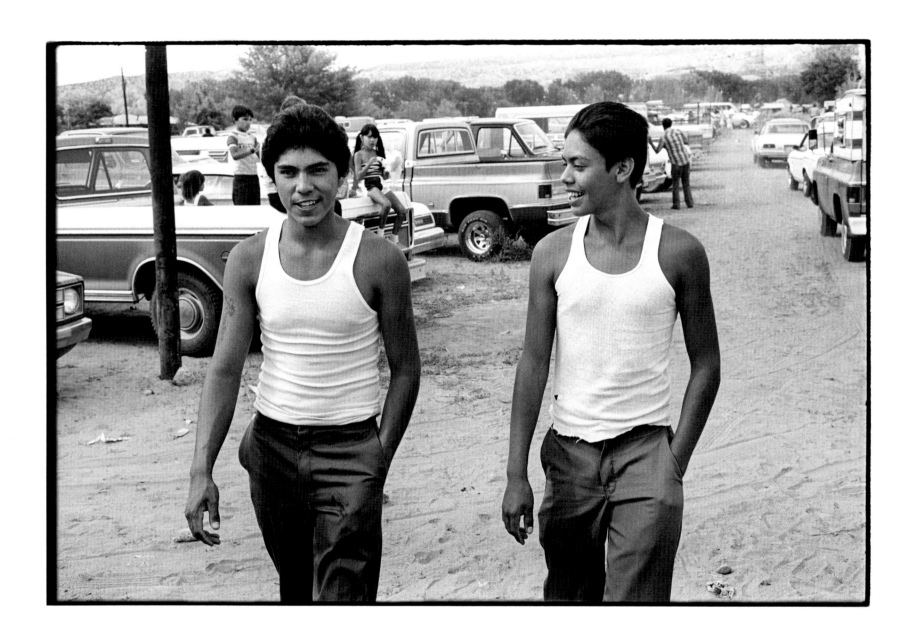

73. Albuquerque, 1982

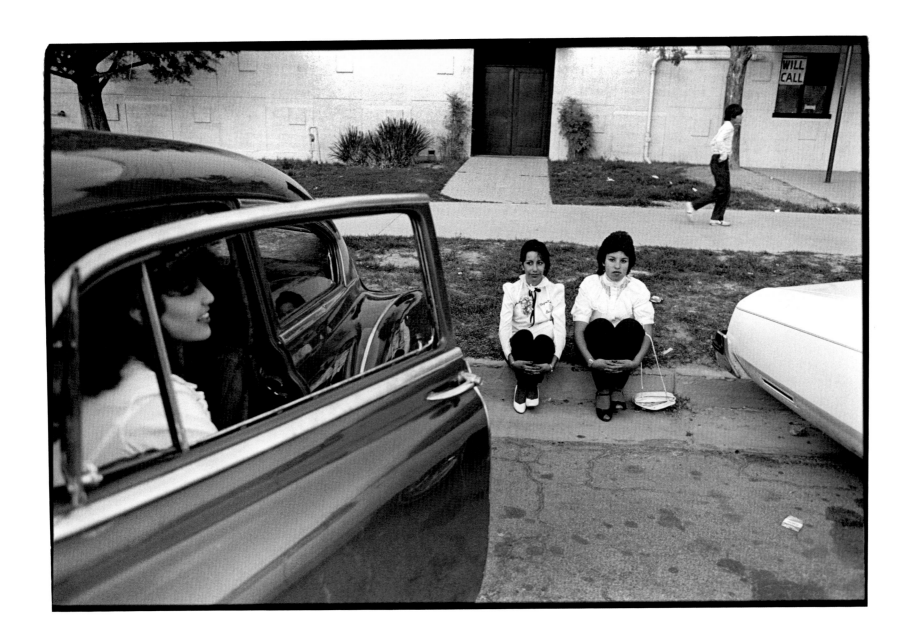

74. First Annual New Mexico Lowrider Car Show and Dance, Albuquerque, 1983

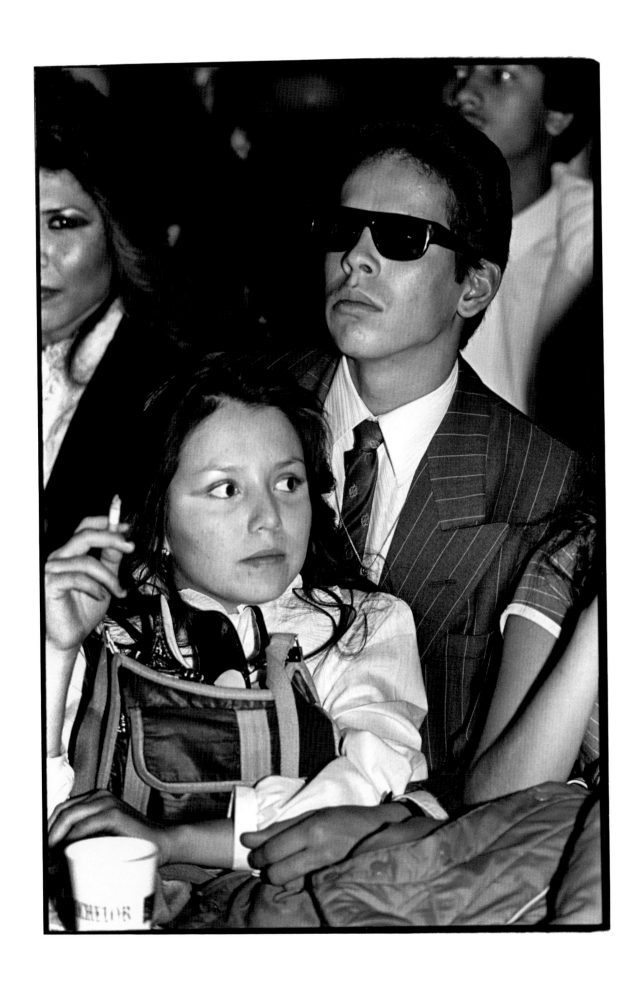

75. First Annual New Mexico Lowrider Car Show and Dance, Albuquerque, 1983

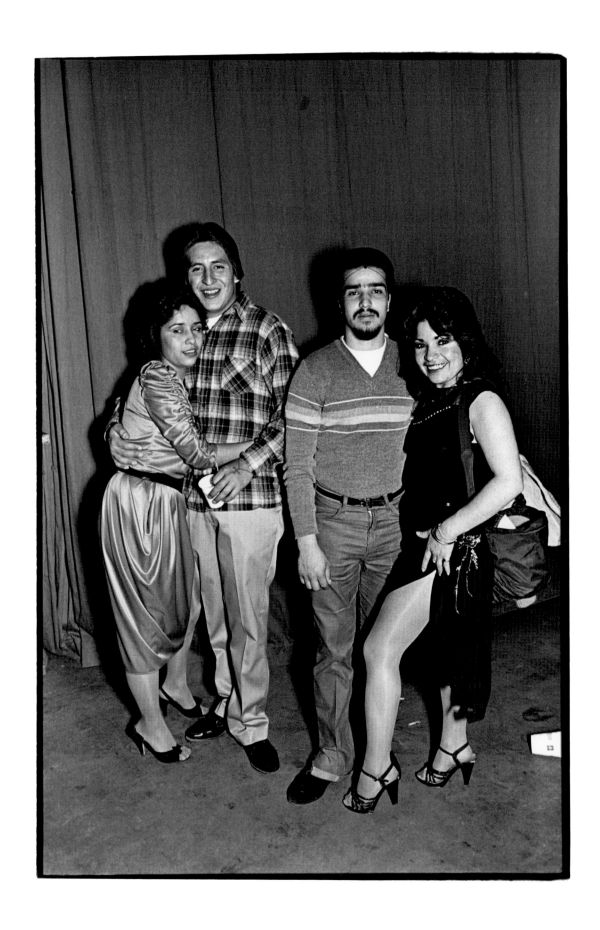

76. Guadalupe Feast Day, Albuquerque, 1982

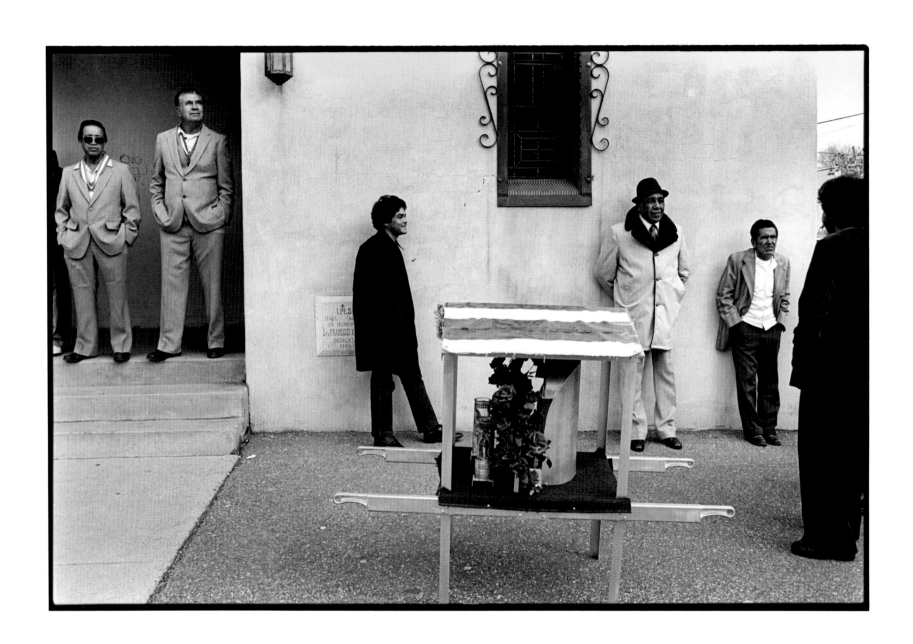

77. Guadalupe Feast Day, Albuquerque, 1982

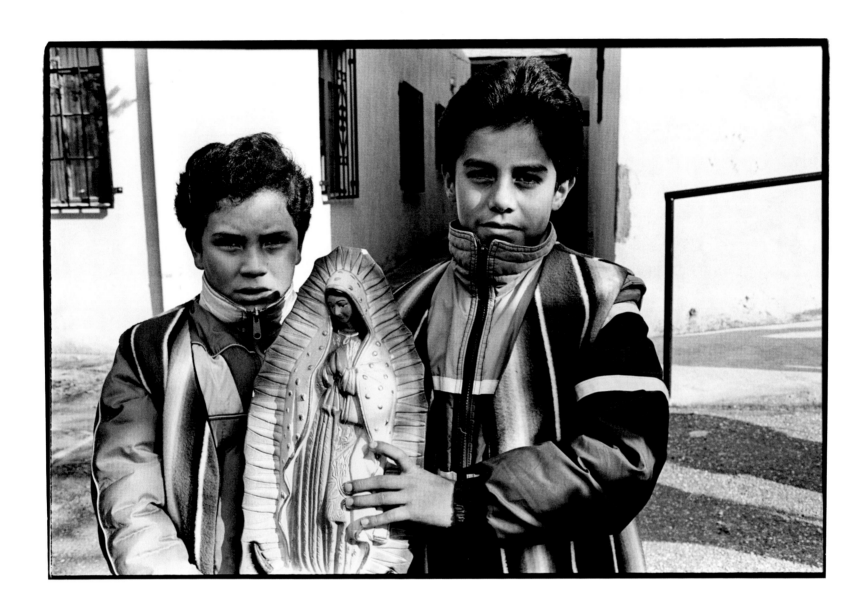

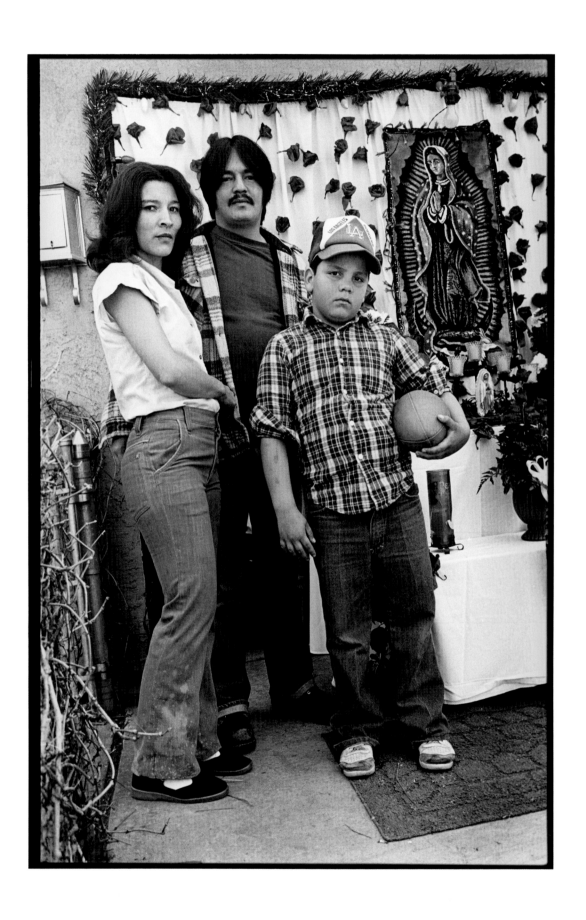

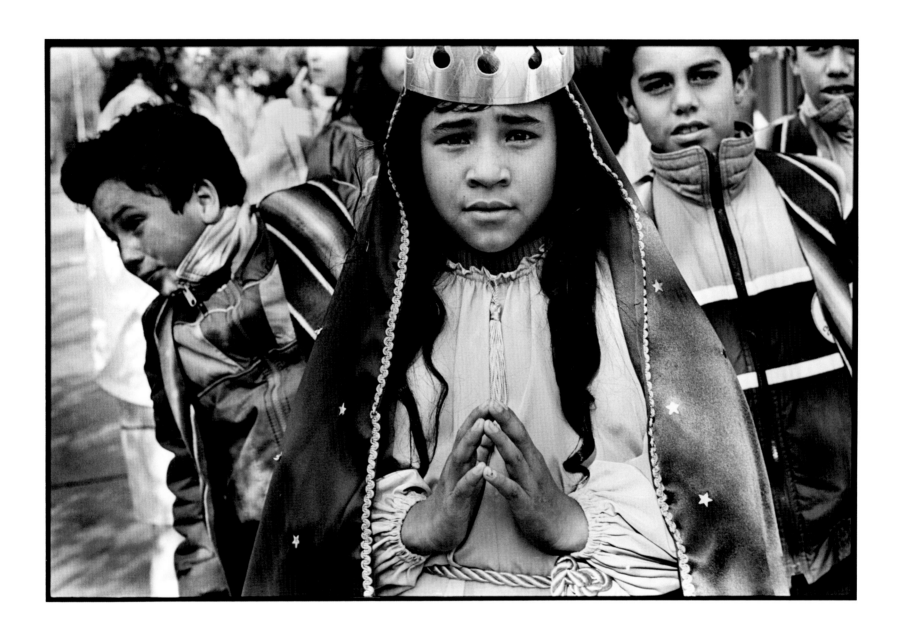

78. Guadalupe Feast Day, Albuquerque, 1982

left: 79. Guadalupe Feast Day, Albuquerque, 1982

80. Las Posadas Pageant, Albuquerque, 1982

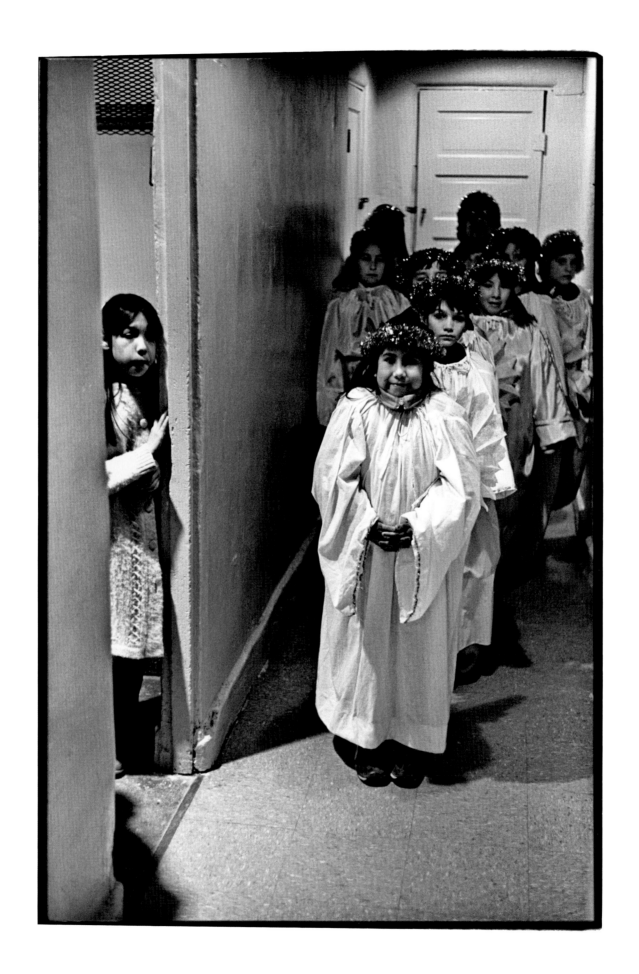

81. Lil Al and Angel Eyes, Albuquerque, 1983

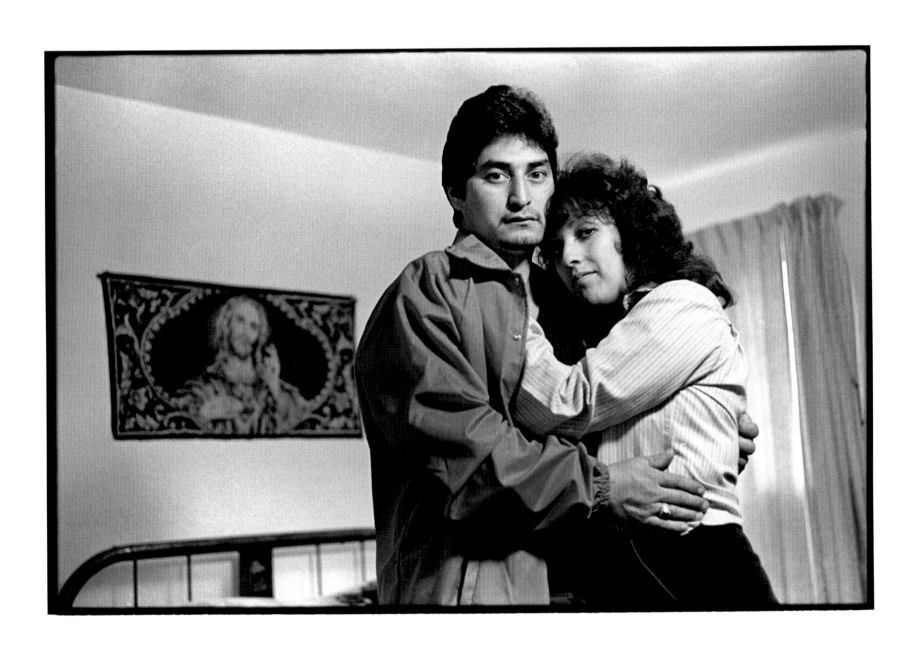

82. Holy Thursday Pilgrimage to Chimayó, Nambé Road, 1981

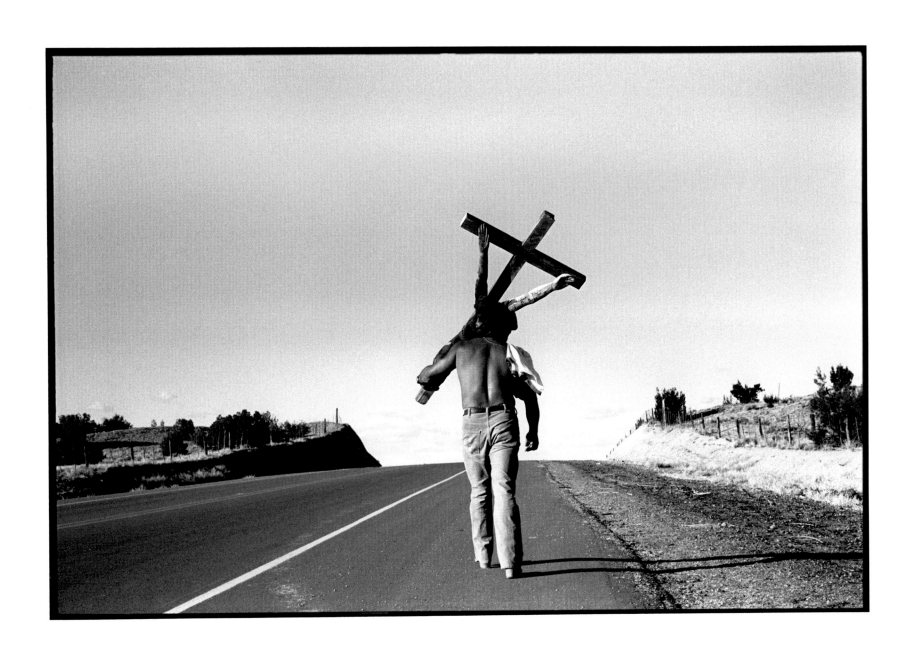

Acknowledgments

My thanks go to all the friends of 1983: Marilyn García, Bernard Plossu, Walter Nelson, William Clark, Brad and Holly Bealmear, Nicholas Potter, Michael Hausman, Pacho Lane, Siegfried Halus, Kitty Leaken, Steve Long, Robert Reck, Terry Husebye, Weston DeWalt, Ricky Stevens, Percy Luján and family, the community of Chimayó, and all of the young people at San Gabriel Park in Albuquerque so many years ago.

I am grateful to Miguel Gandert for his excellent foreword and to Anna Gallegos, Lisa Pacheco, and David Skolkin of the Museum of New Mexico Press who have brought this book to life. Thanks to Kate O'Donnell for her edit of the text, Tyler Lawson for his help scanning negatives, and to John Vokoun of Fire Dragon Color for his fine tuning of the images for book production.

Project editor: Lisa Pacheco
Design and production: David Skolkin
Composition: Set in Century Schoolbook
Manufactured in China
10 9 8 7 6 5 4 3 2 1

Library of Congress Cataloging-in-Publication Data

Bubriski, Kevin, photographer.
 [Photographs. Selections]
 Look into my eyes : nuevomexicanos por vida, '81-'83 / photographs by Kevin
Bubriski ; foreword by Miguel Gandert.
 pages cm
 In English.
 ISBN 978-0-89013-611-9 (hardcover)
1. New Mexico--Social life and customs--Pictorial works. 2. Hispanic Ameri-
cans--New Mexico--Social life and customs--Pictorial works. 3. New Mexico--His-
tory--20th century--Sources. I. Gandert, Miguel A., writer of foreword. II. Muse-
um of New Mexico. III. Title. IV. Title: New Mexico, 1981-1983.
 F797.B87 2016
 972.08--dc23

 2015034927

ISBN 978-0-89013-611-9 hardcover

Museum of New Mexico Press
PO Box 2087
Santa Fe, New Mexico 87504
mnmpress.org

page 1: 1. Holy Thursday, El Santuario de Chimayó, 1982
page 4: 2. Sportsman's Bar, Abiquiú, 1981